A Tale of Today
Yinka Shonibare CBE

T0002684

DRIEHAUS
MUSEUM

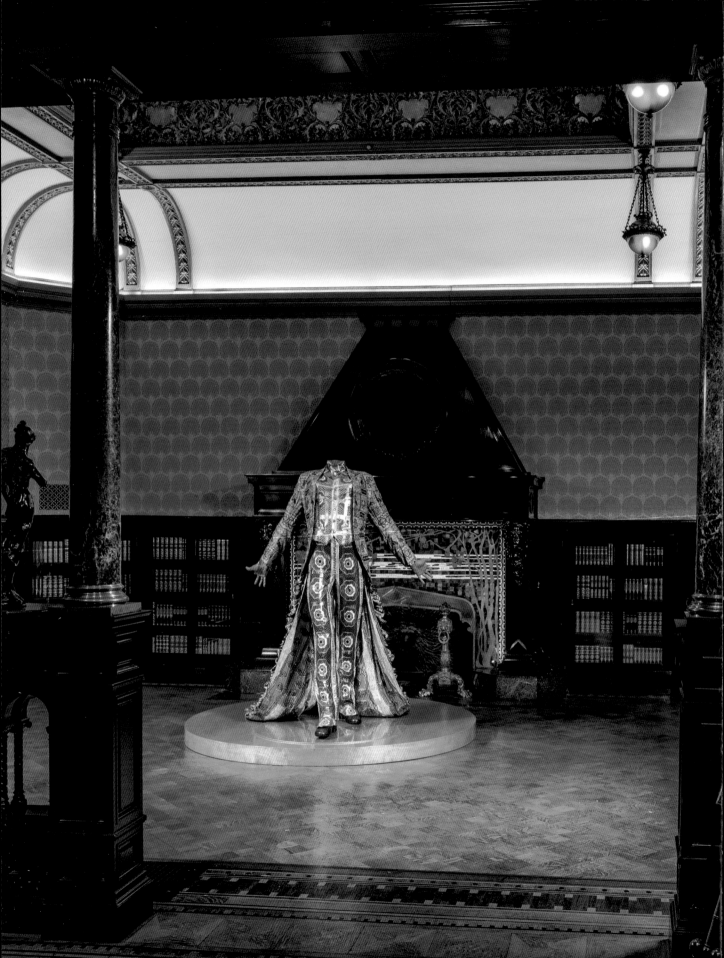

Yinka Shonibare CBE

A TALE OF TODAY

Richard P. Townsend

With an essay by Kirstin Purtich

DRIEHAUS MUSEUM

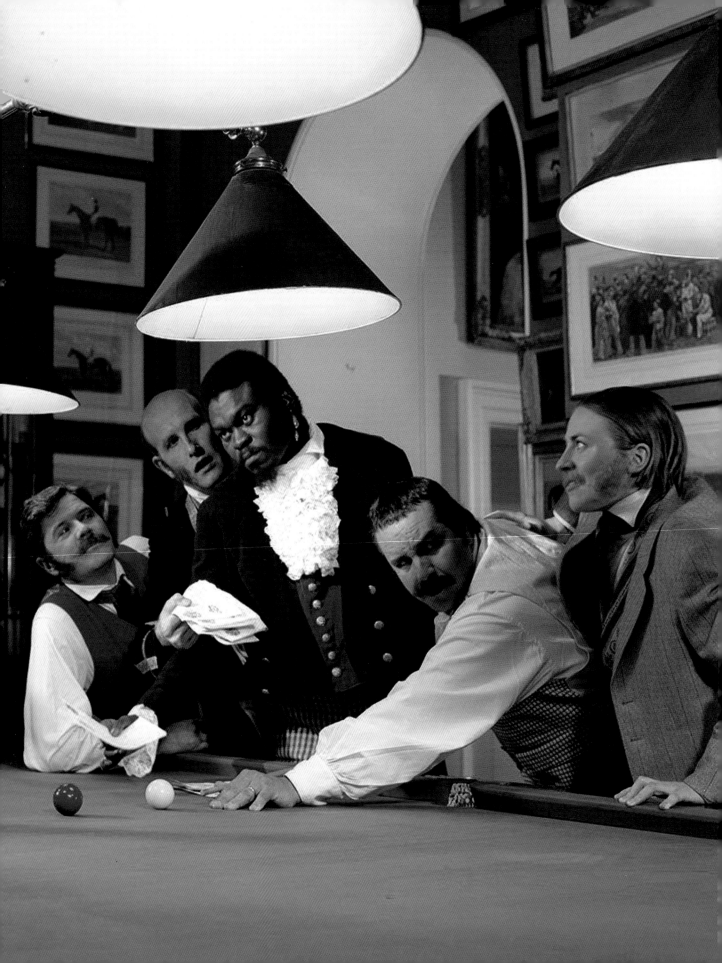

6

Foreword
Richard P. Townsend

10

Fabricating History in the Work of Yinka Shonibare CBE
Kirstin Purtich

20

Out of Whole Cloth
A Conversation with Yinka Shonibare CBE
Richard P. Townsend

33

Catalogue

102

Acknowledgments

FOREWORD

Following up on his first great success, *Innocents Abroad* (1869), in 1873 Mark Twain, with coauthor Charles Dudley Warner, published his first novel–*The Gilded Age: A Tale of Today*. The novel ultimately lent its name to an entire era–an era that the Richard H. Driehaus Museum celebrates through its collections and the building that houses them. The Samuel M. Nickerson Mansion was finished ten years after the novel, in 1883, and was the largest private home in Chicago at the time of its completion; it is one of the most extraordinary and opulent residences of its kind. Its features include a purpose-built art gallery, designed to display the collection of contemporary European and American art amassed by Samuel and Mathilda Nickerson. The Nickersons were movers and shakers in the city's burgeoning cultural community; Mr. Nickerson himself was a founding trustee of the Art Institute of Chicago. Young art students from the School of the Art Institute would come to the gallery to sketch and learn in what turned out to be an incubator of creativity.

Approximately 135 years later, the Driehaus Museum is launching a new exhibition series, fittingly called *A Tale of Today: New Artists at the Driehaus*. With its title taken from Twain and Warner's novel, the series will present contemporary art in a late nineteenth-century environment, allowing these "new" artists to provide meaningful commentary on the Gilded Age and its present-day resonances. *A Tale of Today* will also place artists in our permanent collection in a new light. It will explore not only the craftsmanship and technological virtuosity, the skilled design and artisanship, and the colorful lives of these artists and their patrons such as the Nickersons, but also the underbelly of that moment in American history and culture, whose racial, social, and economic disparities plagued this era of excess and rampant materialism, and now afflict what is being called the Second Gilded Age. Accordingly, *A Tale of Today* emphasizes artists of color, many of whom tackle these themes with a deftness and authenticity that emerges from a burdensome history, giving a contemporary voice to these deep-rooted issues. We invite you to be active participants in these conversations, which will look critically at both the highs and lows of this seminal period in American history and the development of our great city.

There is no more appropriate artist with whom to launch *A Tale of Today* than Yinka Shonibare CBE. Himself a product of the British colonial system, Shonibare's oeuvre critiques, in a dramatic yet humorous way, the course of empire and Victorian mores, and fits seamlessly into the sumptuous interiors of the Nickerson Mansion. My first debt of gratitude is to Yinka himself. I thank him for both his compelling work and his generosity of spirit and time throughout this undertaking, as well as that of his team: Ruth Hogan, Imogen Wright, and Ailbhe Cline. My thanks also go to the artist's gallerist,

Jane Cohan, and the James Cohan Gallery, New York. I am particularly indebted to my friend and colleague Kirstin Purtich, who contributed an insightful catalogue essay and served as an invaluable resource to the project throughout its gestation.

At the Museum, I am grateful to Catherine Shotick, Curator of Collections and Exhibitions; Catherine Nguyen, Registrar; Amelia Anderson, Curatorial Assistant; and our entire staff, all of whom have assisted with the organization of the exhibition. Our exceptional communications team, led by Assistant Director Liz Tillmanns, along with Studio Blue and JNL Graphic Design, developed the present catalogue and promoted a compelling graphic identity for it and the exhibition. Fundraising efforts were greatly aided by Assistant Director of Development Anna Musci and consultant Judi Kamien. I would also like to convey my appreciation to colleagues Ulysses Grant Dietz at the Newark Museum and James Rondeau and Sarah Guernsey at the Art Institute of Chicago, who championed the project in its early, vital phases.

My colleagues and I at the Driehaus are deeply thankful to those who have materially supported this endeavor. First of all, we would like to acknowledge those museums and private collectors who have so generously lent works to the exhibition as well as those who have provided critical financial support in order to make it possible: Eugene and Jean Stark, Gary Metzner and Scott Johnson, and the Richard H. Driehaus Annual Exhibition Fund.

We are very grateful to the Joyce Foundation, especially Ellen Alberding and Tracie D. Hall, for their exceptional support of the Driehaus Museum's new curatorial and artistic fellowship. This two-year pilot program, associated with *A Tale of Today*'s exhibitions, will support local emerging artists of color. Leveraging the exhibition series as inspiration and guided by Curatorial Fellow Kekeli Sumah, we will work with four artists from our community each year to promote their careers using our resources and network. The fellowship speaks to the Driehaus's commitment to deepening the conversation surrounding the representation of artists of color and strengthening our field's efforts to effect real change in this regard.

Finally, we wish to recognize the support of our founder, Richard H. Driehaus. This series—*A Tale of Today*—is yet another tangible example of his extraordinary generosity, which has enriched all of Chicago and which exemplifies his commitment to the community.

Richard P. Townsend
Executive Director
The Richard H. Driehaus Museum

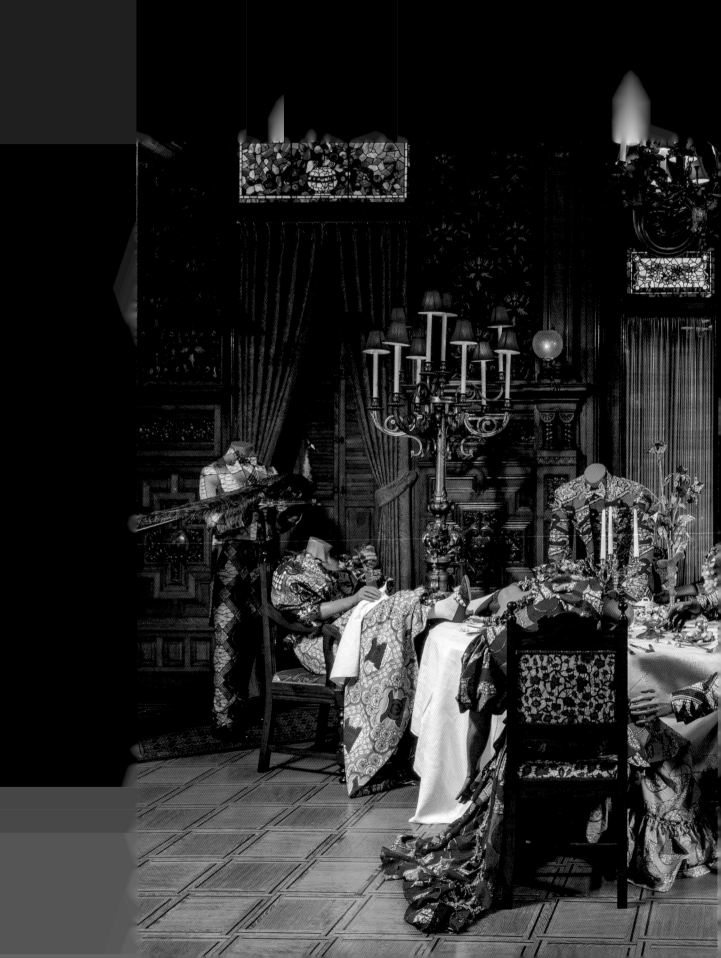

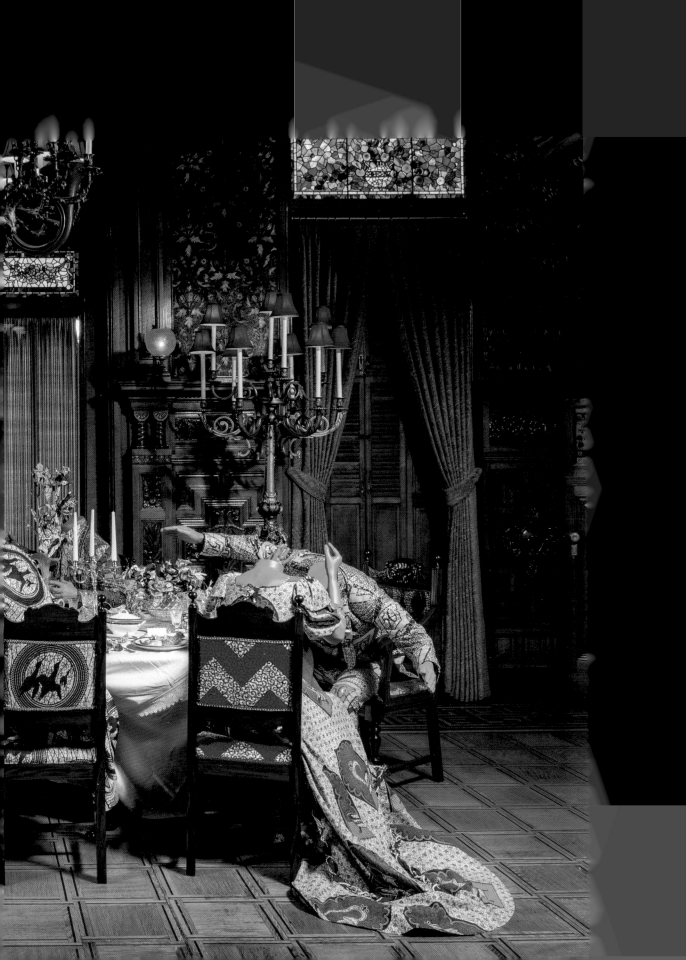

Kirstin Purtich

FABRICATING HISTORY IN THE WORK OF YINKA SHONIBARE CBE

Standing seven feet tall even without a head, Yinka Shonibare's *Big Boy* (2002; **fig. 1**; pages 86–89) cuts an imposing figure. With lean fiberglass arms outstretched and a chest proudly thrust forward, the larger-than-life mannequin exudes the arrogant confidence of a nineteenth-century dandy, an upwardly mobile "Man whose trade, office and existence consists in the wearing of Clothes," first and foremost.[1] The tailoring of the figure's coat, vest, and trousers is impeccable, and a closer look reveals the dandy's characteristic attention to sartorial detail, in the matching pattern of the vest and spats and in the tiepin and watch chain. As the figure steps one leather-shod foot forward, an apparently muscular thigh suggests the slim, French-style trousers that overtook the fuller, English-style cut in the later 1860s **(fig. 2)**.[2]

Within the rich but subdued interiors of the Driehaus Museum, housed in the Samuel M. Nickerson Mansion to the prevailing decorative tastes of Gilded Age Chicago, *Big Boy*'s highly saturated clothing may be jarring. In fact, the garments' bright hues are not so far from the faddish aniline dyes developed in the mid- to late nineteenth century **(fig. 3)**, and the fabrics' patterns aligns with the bold, sometimes gaudy designs made possible by that era's industrial innovations in textile printing.[3] The waist seam of *Big Boy*'s coat suggests post-1880 tailoring, but, as is often the case with Shonibare's tableaux, it may be unnecessary to identify an exact point of reference for this fashionable attire.[4] Working with theatrical costume designers and other collaborators to realize his often-elaborate installations, Shonibare seeks to evoke a period and convey its resonance in the popular imagination, rather than re-create a precise moment in time. As the artist has explained, his "love-hate" preoccupation with the Victorian era—particularly its latter years—derives from living in England, where "one cannot escape all these Victorian things, because they are everywhere: in architecture, culture, attitude."[5]

With the costume's profusion of patterns, *Big Boy* seems to renounce what the early twentieth-century psychologist J. C. Flügel termed the "Great Masculine Renunciation," in which the majority of Western men gave up color and decoration in fashion in favor of an austere, ostensibly equalizing

1. Thomas Carlyle, *Sartor Resartus: On Heroes and Hero Worship* (London: J. M. Dent; New York: E. P. Dutton, 1954), 204. For more recent appraisals of the dandy and of men's fashion more broadly, see Kate Irvin and Laurie Ann Brewer, eds., *Artist/Rebel/Dandy: Men of Fashion* (New Haven: Yale University Press/Museum of Art, Rhode Island School of Design, 2013); and Sharon Sadako Takeda, Kaye Durland Spilker, and Clarissa M. Esguerra, *Reigning Men: Fashion in Menswear, 1715–2015* (Los Angeles: Los Angeles County Museum of Art; Munich, London, and New York: Prestel, 2016).

2. "Observations on Fashions," *West-End Gazette of Gentlemen's Fashion*, April 1867, 15.

3. Linda Parry, *British Textiles from 1850 to 1900* (New York: Canopy, 1993), 9–10.

4. Christopher Breward, *The Hidden Consumer: Masculinities, Fashion and City Life, 1860–1914* (Manchester and New York: Manchester University Press, 1999), 32–33.

5. Jaap Guldemond and Gabriele Mackert, "To Entertain and Provoke: Western Influences in the Work of Yinka Shonibare," in *Yinka Shonibare: Double Dutch*, ed. Jaap Guldemond, Gabriele Mackert, and Barbere Kooij (Rotterdam: NAi, 2004), 38.

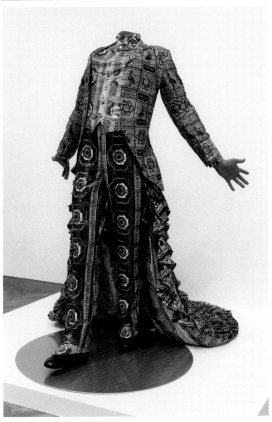

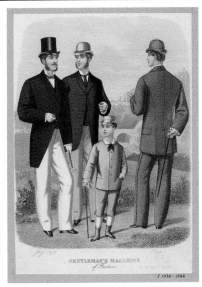

Fig. 2. Fashion plate from the *Gentleman's Magazine of Fashion*, July 1878. Hand-colored lithograph. Victoria and Albert Museum, London, E.1039-1946

Fig. 1. Yinka Shonibare CBE (British/Nigerian, b. 1962)
Big Boy, 2002. Wax-printed cotton fabric and, fiberglass
The Art Institute of Chicago, Gift of Susan and Lewis Manilow, 2004.759

Fig. 3. Day dress, ca. 1873. Great Britain or France. Silk (colored with synthetic dyes belonging to the methyl violet, and aniline blue families) and whalebone, Victoria and Albert Museum, London, Given by the Marchioness of Bristol, T.51&A-1922.

Fig. 4. John Leech (English, 1817–1864), "A Most Alarming Swelling!" Illustration for *Punch*, 1850. Wood engraving. New York Public Library, The Miriam and Ira D. Wallach Division of Art, Prints and Photographs: Picture Collection. Shelf locator: PC COSTU-185-En

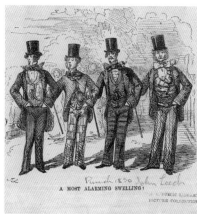

uniform.[6] Subsequent scholars have noted that ostentation hardly disappeared from men's fashion in the Victorian era, though the most conspicuous adopters of modish stripes and plaids might be mocked as dandies or "swells" **(fig. 4)**.[7] Moreover, the ruffled train of *Big Boy*'s coat is decidedly more suggestive of contemporaneous women's attire, laying bare the provocative gender fluidity of the late nineteenth-century dandy. Considering Shonibare's frequent, playful miscegenation of history and popular culture, it may not be surprising to learn that *Big Boy* was inspired in part by RuPaul.[8]

Of course, the contemporary fabrics that clothe *Big Boy* are not meant to be period appropriate; they are the textiles popularly known as "African print" or "Dutch wax," which have been a mainstay of the artist's mixed-media work in painting, sculpture, and film for over twenty years now. Neither wax-resist printed nor strictly Dutch or African, this type of textile has its roots in nineteenth-century European colonization of the African continent. Shonibare deploys modern iterations of the product to explore complex and wide-ranging ideas about hybrid cultural identity, informed by his own experience as a British-born Nigerian artist.

These patterned textiles have been widely recognized as signifiers of Africanness since the 1960s, but this identification results from several stages of reappropriation. Originally, these fabrics derived from the traditional batik technique developed in Indonesia, in which hot wax is drawn by hand onto the surface of a cloth using a pen-like tool called a *tjanting*; the design may need to be copied on the opposite face of the fabric before dyeing to ensure the areas covered with wax will resist the dye and produce a clear surface pattern. After reconquering Indonesia in the early nineteenth century, the Dutch sought

6. John Carl Flügel, *The Psychology of Clothes* (London: Hogarth Press, 1950), 110-12.

7. Brent Shannon, *The Cut of His Coat: Men, Dress, and Consumer Culture in Britain, 1860-1914* (Athens: Ohio University Press, 2006), 6-7.

8. Judith F. Dolkart, *Yinka Shonibare MBE: Magic Ladders* (Philadelphia: Barnes Foundation, 2014), 24.

9. Helen Elands, "Dutch Wax Classics: The Designs Introduced by Ebenezer Brown Fleming circa 1890-1912 and Their Legacy," in *African-Print Fashion Now! A Story of Taste, Globalization, and Style*, ed. Suzanne Gott et al. (Los Angeles: Fowler Museum at UCLA, 2017), 53.

10. John Picton, *The Art of African Textiles: Technology, Tradition and Lurex* (London: Barbican Art Gallery/Lund Humphries, 1995), 26.

11. Elands, "Dutch Wax Classics," 54-59.

12. Ibid., 54. See also Ruth Nielsen, "The History and Development of Wax-Printed Textiles Intended for West Africa and Zaire," in *The Fabrics of Culture: The Anthropology of Clothing and Adornment*, ed. Justine M. Cordwell and Ronald A. Schwarz (The Hague, Paris, and New York: Mouton, 1979), 471.

a more efficient alternative to this labor-intensive production method, with the goal of undercutting local manufacture with a cheaper textile. Following the departure of Flemish textile production with Belgium's secession from the Netherlands in the 1830s, the Dutch hoped that an imitation batik could help shore up their own textile industry.

By 1854 the Belgian textile manufacturer who ran the Haarlem Cotton Company's printworks—Jean-Baptiste Théodore Prévinaire—had adapted the flat blocks of a French banknote-printing machine to print a hot resin paste on both sides of a cloth. In 1875 Prévinaire's son streamlined this mechanical process further with the introduction of duplex rollers.[9] Because this resin-resist cracked unpredictably as it cooled, telltale veins of blue would appear in the designs when the fabric was dipped into an indigo dye bath and left to oxidize; more significantly, the resin proved difficult to remove completely, leaving spots behind when the fabric was overprinted with additional colors.[10] These industrial imperfections were undesirable to Indonesian consumers, but the fabrics found a willing market in the colonies of West Africa, where increased wealth, a taste for high-quality cloth from India and Indonesia, and similar domestic techniques of textile finishing were all factors in the products' success.[11] This fortuitous diversion of goods has been credited largely to the agency of the Glasgow merchant Ebenezer Brown Fleming, whose connections to the Prévinaire family and to Gold Coast missionaries offered him unique access and insights on both sides of the market.[12]

Recent research into extant samples of early wax prints has shown how textiles developed for the colonial market could directly reflect the exchange of European and African symbols and ideas. A 1913 design registered by

Fig. 5. Factory-printed wax-print cloth sample. Registered by Ebenezer Brown Fleming, August 9, 1913. BT 52/2944/90669

Brown Fleming **(fig. 5)**, for instance, incorporates motifs long established in West African textiles—like the open-palm "Hands and Fingers"—as well as imagery associated with the fraternal order of the Oddfellows, established in 1879 during British colonial rule of the Gold Coast.[13] This cloth also displays the characteristic veining and irregular application of color noted above. While Brown Fleming maintained a monopoly on this niche textile trade until about 1910, competitors in the Netherlands, Britain, and Switzerland began to develop similar design and manufacturing processes. Two of these companies—Van Vlissingen and F. W. Ashton and Co.—still operate to this day, as Vlisco and ABC Wax, respectively.

During the decolonization of Africa and the Pan-African movement of the mid-twentieth century, these trade goods of European origin underwent an ideological transformation, in which their consumers claimed the textiles as markers of a native cultural identity. Shonibare himself has recalled wearing such fabrics during his childhood in Lagos in the 1960s and 1970s: like his father, who would change from a suit into a Yoruba gown known as *agdaba* when he returned from work, the young Shonibare switched from his Western-style school uniform to a more "relaxed, 'African' type of clothing" for at-home wear.[14]

It is this postcolonial web of markets and meaning that Shonibare engages with his use of African-print textiles in the present day. Shonibare's earliest works utilize a combination of resin-resist textiles and still-cheaper copies with similar motifs, which feature designs printed on just the front face of the fabric; these latter "Java prints" and "fancy prints" are manufactured today in Africa and Asia.[15] However, all the works in the present exhibition highlight the artist's later, deliberate focus on European-made textiles sold in London's

13. Julie Halls and Allison Martino identify the links that join two hearts, the clasped hands, and the "Eye of Providence" as possible allusions to the Oddfellows, but they also note that the textile may deploy these common fraternal symbols in order to capture a wider market. Julie Halls and Allison Martino, "Cloth, Copyright, and Cultural Exchange: Textile Designs for Export to Africa at the National Archives of the UK," *Journal of Design History* 31, no. 3 (September 2018): 248–49. See also similar discussions by Elands, "Dutch Wax Classics," 55; and Picton, *The Art of African Textiles*, 28–29.

14. Yinka Shonibare, unpublished talk, 1997, quoted in John Picton, "Laughing at Ourselves," in Guldemond, Mackert, and Kooij, *Yinka Shonibare: Double Dutch*, 46.

15. John Picton, *The Art of African Textiles*, 30n44.

16. John Picton, "Undressing Ethnicity," *African Arts* 34, no. 3 (Autumn 2001): 69.

17. Guldemond and Mackert, "To Entertain and Provoke," 41.

18. Hansi Momodu-Gordon, "In the Making: African-Print Fashion and Contemporary Art," in Gott et al., *African-Print Fashion Now!*, 265.

19. Patricia Campbell Warner, *When the Girls Came Out to Play: The Birth of American Sportswear* (Amherst and Boston: University of Massachusetts Press, 2006), 104. For a more detailed history of the fad, see Robert A. Smith, *A Social History of the Bicycle: Its Early Life and Times in America* (New York: American Heritage Press, 1972).

20. Rachel Kent, "Time and Transformation in the Art of Yinka Shonibare MBE," in *Yinka Shonibare MBE*, ed. Rachel Kent (Munich, London, and New York: Prestel, 2014), 10.

Brixton Market, which draw attention to the fabrics' purported authenticity.[16] As Shonibare noted in a 2004 interview, "it is important that I don't go to Africa to buy [the fabrics], so that all African exotic implications remain fake."[17] As Hansi Momodu-Gordon has argued more recently, Shonibare's "use of African print enables an investigation of the constituents of 'European-ness' as much as it is an assertion of a so-called African identity."[18]

Like these multivalent textiles, the bodies of Shonibare's figures play with ambiguity and defy easy interpretation. With their light-brown "flesh," are we to read these figures as British colonizers or as the colonized themselves? As part of a series examining literal and figurative mobility, *Child on Unicycle* (2005; page 90–93) seems to indicate a more defined era, namely, the cycling craze of the late 1880s and 1890s.[19] In his tailored knickerbocker suit, the boy balances triumphantly, his upward motion mirroring the capitalist success of the colonially derived fabrics he wears. However, his headless body heightens the precariousness of his vehicle as well as the global market. These headless mannequins might not appear out of place in a fashion exhibition, but the missing appendages are especially uncanny in light of the figures' incredibly lifelike hands.

Shonibare has admitted that his headless figures allude in part to the guillotine deaths of aristocrats and royals during the French Revolution, and there is certainly a diachronic suggestion of looming class conflict in *Party Time: Re-imagine America* (2009; page 94–101, 103).[20] Transplanted from its site-specific installation at the Newark Museum's Ballantine House (1885) to the Nickerson Mansion's dining room (1883), this multifigure installation features the arrested bodies of raucous upper-class dinner guests and a comparatively meek and

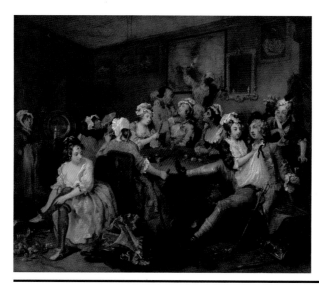

Fig. 6. William Hogarth (English, 1697–1764), *The Rake's Progress: The Orgy (The Tavern)*, 1735. Oil on canvas, Sir John Soane's Museum, London

genteel servant, who arrives with a peacock on a platter to highlight the absurd avarice and social stratification of turn-of-the-century America. A setting of overly specialized utensils and a gluttonous, half-consumed meal rendered in plastic resin complete this scene of excess: sloshing wine is frozen in time, while plates are laden with preternaturally green lettuce and glistening oysters, a wildly popular food among all socioeconomic classes in the United States in the latter nineteenth century.[21] These props serve as theatrical decoration, while *Upstairs, Downstairs* (1997; page 34–35), the earliest work in this exhibition, employs fine tableware as a medium for the artist's message. Displayed against a photograph of an eighteenth-century country house—Liverpool's Croxteth Hall, the former home of the Earls of Sefton—a porcelain service creates an "impression of heritage" with traditional floral patterns in acidic colors, and its inscriptions confront convention as well.[22] Rather than commemorating an aristocratic owner, each of the sixteen plates lists the name and role of one of the invisible servants who kept such a lavish estate running, from "Taylor Charles, Head Coachman" to "Mawdley Alice, Poultrywoman."

In *Party Time: Re-imagine America*, Shonibare's signature textiles are everywhere, from the flowers in the ornate centerpieces to the chairs' upholstery, to, most importantly, the figures' ensembles. Here, traditional Western divisions of male and female clothing are upheld in cut if not in fabric, while the "proper-proper" morals and behavior we might expect from a semipublic Victorian social occasion have been upended.[23] Most shocking is the appearance of the apparent hostess's feet atop the table; although the frilled hems of her drawers are visible and she seems to lack any petticoats, at least her scandalously exposed calves and ankles are concealed appropriately in white stockings.[24]

21. Mark Kurlansky, *The Big Oyster: History on the Half Shell* (New York: Ballantine, 2006), 214. On private dining in this era more broadly, see Cindy R. Lobel, *Urban Appetites: Food and Culture in Nineteenth-Century New York* (Chicago and London: University of Chicago Press, 2014), 139–67.

22. Melissa E. Feldman and Ingrid Schaffner, *Secret Victorians: Contemporary Artists and a 19th-Century Vision* (London: Hayward Gallery, 1998), 52.

23. Shonibare quoted in Guldemond and Mackert, "To Entertain and Provoke," 38.

24. Philippe Perrot, *Fashioning the Bourgeoisie: A History of Clothing in the Nineteenth Century*, trans. Richard Bienvenu (Princeton: Princeton University Press, 1994), 146–48, 160.

25. Stella Blum, ed., *Victorian Fashions and Costumes from "Harper's Bazaar," 1867-1898* (New York: Dover, 1974), 227–29.

26. Richard P. Townsend's interview with Yinka Shonibare, this volume, 25.

27. Monica L. Miller, *Slaves to Fashion: Black Dandyism and the Styling of Black Diasporic Identity* (Durham and London: Duke University Press, 2009), 278–82.

28. Ibid., 287.

29. Guldemond and Mackert, "To Entertain and Provoke," 41.

Rather than replicating the distinctive skirt of the mid- to late 1880s, with its shelf-like bustle, the women's dinner gowns anticipate the following decade's hourglass silhouette and ballooning sleeves.[25] The dresses' low necklines would have been acceptable for 1890s evening wear, though their exposure of heaving bosoms defies our contemporary notions of nineteenth-century decorum; the absence of gloves, on the other hand, would have been much more conspicuous to a Victorian than it is to us today.

Compared to the sculptural installations that have become Shonibare's signature medium, the photographic series *Diary of a Victorian Dandy* (1998; page 37–51) and *Dorian Gray* (2001; page 53–85) offer a differently mediated interpretation of Victorian England, adding the dimension of time and the visual rhetoric of film. In each of these narrative series, the conceit of African-print or Dutch-wax textiles is stripped away, in order to focus on a costume drama starring the artist himself.[26] The *Diary* suite reads as a didactic tale in the manner of William Hogarth's *Rake's Progress* **(fig. 6)**, in scenes carefully staged in an authentically English stately home, originally exhibited in the tunnels of the London Underground. Shonibare illustrates themes of lust, pride, and greed in five large-format snapshots of a day in the life of the titular dandy, although he is never served the comeuppance that Hogarth's rake receives for his debauched behavior. Instead, Shonibare "practic[es] a redemptive narcissism" by positioning himself as the black dandy at the focus of these vignettes, far from the marginalized black servants in Hogarth's upper-class scenes but still inherently cast as an outsider.[27]

While the *Diary* series is entirely invented, *Dorian Gray* presents a familiar vision of late Victorian London, albeit filtered through 1940s Hollywood.

Fig. 7. Ivan Albright (American, 1897–1983), *Picture of Dorian Gray,* 1943–44. Oil on canvas. The Art Institute of Chicago, Gift of Ivan Albright, 1977.21

Shonibare's retelling of Oscar Wilde's serialized novella closely resembles the 1945 film adaptation released by Metro-Goldwyn-Mayer, from the twelve scenes that evoke promotional lobby cards to the inclusion of a single chromogenic print. The latter has the same dramatic impact as the film's four brief interludes of Technicolor, though Shonibare does not attempt to fashion his own version of the Chicago painter Ivan Albright's grotesque vision of Dorian's corrupted portrait (**fig. 7**). In fact, Shonibare substitutes a mirror for the painting, his disfigured face indicating that black Dorian cannot escape punishment the way the original, white Dorian could.[28] The costumes that Shonibare and his fellow characters wear are neither painstaking re-creations of Victorian fashion plates nor direct allusions to the film's 1940s-influenced tailoring. Instead, staging and light effects do much of the work to generate the atmosphere of the story's setting and the downfall of the decadent dandy.

In these installations and photographs, Shonibare plays with historical memory, his critiques of Victorian England and Gilded Age America always tempered by a witty sense of humor. Whether clothing headless figures in former trade textiles or casting himself in a period drama, Shonibare engages in a deliberate process of seduction and subversion through the appealingly tactile medium of textiles and dress. As the artist himself has defined his approach: "I am here to protest, but I am going to do it like a gentleman."[29]

Richard P. Townsend

OUT OF WHOLE CLOTH
A CONVERSATION WITH
YINKA SHONIBARE CBE

Richard P. Townsend: *In this moment where our culture is a deluge of the fake, the lie—how do you position yourself and your work? I think that your art is trying to get at the truth, but in an artful way. And artfulness involves artifice. What do you think about the state of affairs today and how do you relate to it?*

Yinka Shonibare CBE: I think that the whole issue of authenticity, which is what you're talking about, can be misused, and can also be a means of stereotyping people. And so, my work came into being at a time when language itself was being questioned. And the whole issue of deconstruction was kind of an issue that a lot of people were trying to look at.

My work really evolved out of French Continental theory: looking at what the signs are, what they mean, and, basically, taking them apart and saying, "Actually, people are not what you are saying they are." History itself, we know, is very subjective anyway. And history is always written from the points of view of the people with power. And that, then, is brought forward as the authentic point of view. But, of course, we all know that it's all about power. That's what history is. Then, what happens to the people who are being subjected to that kind of lie, as it were, or that fallacy? I'm interested in the agency of those people to actually take control of their own history and own it, and then tell their own stories.

RPT: *But we can figure out the truth through our own experience. Isn't that what art is essentially about?*

YS: Well, for me, the notion of truth, in a sense it's relative, because one person's truth is another person's lie. I don't think there is such a thing as the ultimate truth. And we want to be really careful about that, because ideology is always based on this notion of the ultimate truth. And, certainly, the ultimate

truth in that way, unfortunately, could also lead to the ultimate solution. And you don't want things like that to happen. We've experienced that in history, and that's where we have to actually be very careful about whose truth it is. Because there are many perspectives, and we need to understand things from their point of view. But I think ultimate truth, in my opinion—and history actually shown this—then leads to dictatorships, and we don't want that.

> **RPT:** *So, Yinka, please tell me something about your approach to historicity. You were segueing into that, obviously, from the last question. Yours is not an archaeological approach. You've mixed motifs, styles, and periods to great effect. But tell me a little about how this fluidity of chronology and style works for you as a device and its significance in your work.*

YS: Well, for me, art is a form, artifice, and it is make-believe. Say if I want to mix the nineteenth century with the medieval, I can do that as an artist, because I'm taking you to places that don't exist anyway in the first place. I don't have any problems with doing that. I don't see myself as trying to sell some kind of truth story. In a way, actually, with art it's the biggest kind of lie ever, because you're basically fabricating. It is artifice, after all. It's poetic license—within poetry you can do things that you don't necessarily do in speech. And I think art is kind of the same way.

> **RPT:** *Speaking of the historical, you've made something of a specialty working with Victorian settings and characters as early as your* Victorian Philanthropist's Parlor *(1996-97). But with* Party Time: Re-imagine America *(2009; pages 94-101, 103), commissioned by the Newark Museum in 2009 for their 1885 Ballantine House, you began to make work for actual Victorian environments. Tell us your thoughts on having your*

work displayed at the Driehaus Museum, the former Nickerson
Mansion of 1883 in Chicago, one of the most opulent nineteenth-
century interiors in the United States.

YS: Nineteenth-century interiors, for me, evoke colonialism. So, in a way there is a kind of intrusion that I like to make into those spaces. It's almost like trying to reverse time, because I, perhaps, wouldn't have been allowed to go into those places, or even eat in those places, or socialize in those places. Obviously, because of the civil rights movement, I'm now able to actually enter those spaces and, in a way, talk back to that history. And I think that's what my work is doing. It's trying to have some kind of conversation with that relationship, my own history and my own background. How do I speak back to history, in that sense? And so, my work tries to do that, but, also, in a kind of playful, humorous way. After all, the work really is about agency. It's not about making myself look passive or pathetic. And it's not about feeling sorry for my ancestors. It's actually about coming back and being playful with some of those things. Some of it is very serious. But at the same time, I think satire and humor are actually very, very important.

This takes me back to the work of William Hogarth. He came from a poor family and was familiar with debtor's prison, in fact. But then as a painter, he did the most humorous parodies about the aristocracy in England. And he was kind of getting his own back, in a way. So, there's a degree of that satire and humor that's important to the work.

RPT: *Well, satire is a device by which one can reveal the truth, no? Or come closer to the truth. That's what Hogarth was doing in his great anecdotal series such as* The Rake's Progress *(1735; page 16, fig. 6) or* Marriage à la Mode *(1743).*

YS: Yes. Particularly if historically you haven't had the power. But then you do have the power of humor and parody, as well.

RPT: *Speaking about history, of course, again, the grand scheme of history, the return of moments of crisis and social injustice. The racial, social, and economic disparities that defined the Gilded Age, the late nineteenth century, about*

which you've spoken so eloquently in your own work, the grandeur as it were, but grandeur on the backs of millions across the globe, seems to be reoccurring.

YS: Yes.

RPT: *So, do we live in a second Gilded Age, where this extraordinary wealth and abundance is once again accompanied by the cost of it all?*

YS: The disparities are huge. There are a lot of people who feel that they're left out…it's almost like we're going back to the nineteenth century. I think that issue needs to be resolved, because, unfortunately, we know what happens when you have that kind of large discontent—it often doesn't end very well.

RPT: *But what can we do, we in the creative community? How should we address this?*

YS: We can't actually do much, other than voting. Because artists can't really change things in that way. Artists can make people think and have a conversation, but, ultimately, you are talking about the population at large. So, getting people out to vote might be a more effective way than anything that I might be doing in my studio.

And, of course, activism. We know that activism over time has actually worked. You can think about Gandhi. You can think about Martin Luther King, Nelson Mandela. Martin Luther King did it peacefully. Gandhi did it peacefully.

RPT: *Is art or can art be an agent of change?*

YS: Well, absolutely, but I wouldn't really advocate art in the utilitarian sense of it. I think art is for the soul and the spirit; it is not a hammer. Yes, in a way that philosophy can lead to change in government policy. But it's not philosophy in itself that will change government policy—it's people who have absorbed philosophy, and thinking people, who then do something. Art can have that kind of secondary impact. But I don't think that it's the art that's actually going to change things.

RPT: *Yinka, would you please speak about your earlier life and career, one or two of your most formative experiences growing up as a boy in Lagos and later, when you were in art school in London, at the Byam Shaw School of Art and then at Goldsmiths?*

YS: Well, I grew up in Lagos, and my interest in art began there. I used to go to children's art workshops on the weekend at the museum in Lagos. There's an ethnographic museum in Lagos. And I did see the works of a lot of Nigerian artists when I was young. There's an artist called Ben Enwonwu, a famous Nigerian artist. I saw his work when I was young. That made me want to pursue art as a career.

And so, I guess it all started when I lived in Nigeria. And then I came to art school in London, and my idea of art sort of changed. I had exposure to Pop art, conceptual art, the kind of art I'd never seen before, performance art. And then I started to actually relate history and philosophy to the making of art. And then when I went to Byam Shaw School of Art in London (and now part of Central Saint Martins in London), my work got very political in my second year.

I was making work about perestroika, which was what was happening in the former Soviet Union at the time. And one of my teachers said to me, "Why are you making work about what's going on in Russia? Why aren't you making authentic African art?" And so, the whole question around the issue of authenticity actually began from that point on. And I wondered what stereotypes were about, and where do we get this idea that something has to be authentic. And that's where my question around that issue began.

RPT: *My first exposure to your work was in Cincinnati at the 2003 opening of the new Zaha Hadid-designed building for the Cincinnati Contemporary Art Center, and its inaugural exhibition,* Somewhere Better Than This Place, *which introduced the general public to the upcoming artists of the day. And, of course, you were one of them. It was there that I first saw* Dorian Gray *(2001; pages 53–85), the photographic suite. I will never forget the impression that made on me.*

Dorian Gray *is a work of stark contrasts. The obvious contrast is between the world of the privileged white class*

1. For discussion of Shonibare's use of Dutch-wax prints, see Kirstin Purtich's essay, this volume, 12–15.

2. The artist was diagnosed with transverse myelitis at the age of 18. See his comments on this in *The Guardian*, January 4, 2013.

3. *The Picture of Dorian Gray* (1945), directed by Albert Lewin and starring George Sanders, Hurd Hatfield, Donna Reed, and Angela Lansbury. Released by MGM.

and their servants, and the black protagonist, which was you. Another is the high contrast you so effectively used between black-and-white photography and the one frame of Technicolor, so to speak. Yet another would be that Dorian—*and this has been remarked on before—and your earlier* Diary of a Victorian Dandy *(1998; pages 37–51) are pretty much the sole exceptions in your work that do not employ your signature African-print textile [or Dutch-wax cloth].*[1]

Is this because the signifier in all of these other works— the African-print cloth—has been replaced by your person in these two series? You are the signifier; you and your proper Victorian attire is all that's needed, and not the device of the European-produced African-print cloth?

YS: Yes, I do use African textiles in my work, but the work is also about me and it's subjective. And so, in a way you're right. I think that at that point, I didn't need to use the textiles; I felt that my presence in those works was quite enough. In *Diary of a Victorian Dandy*, I was reinterpreting Hogarth's *Rake's Progress* in that work, and in *Dorian Gray*, I was exploring Oscar Wilde's *The Picture of Dorian Gray* (1890). But I also wanted to touch on the issue of mortality, the body, and it is probably the first work in which I explicitly explored my own physical disability, too.[2] And I felt that that story was a good story to explore those things.

RPT: *I was quite shocked by it—this whole Hogarthian setting with this black man. It was completely unexpected. I loved that. You completely intended to shock and to discomfit, and it worked beautifully. Tell me a little about your using a 1945 Hollywood film.*[3] *You could have simply composed your own photographed scenes of your own making from this Victorian novella.*

YS: Well, I felt that *The Picture of Dorian Gray*, to a lot of people in popular culture anyway, that film would be one that a lot of people would know. People would also know the book. But I wanted that reference because I was using photography and I wanted to kind of bring it back to new media and then make

4. On the role of the dandy in Shonibare's work, see Jaap Guldemond and Gabriele Mackert, "To Entertain and Provoke: Western Influences in the Work of Yinka Shonibare," in *Yinka Shonibare: Double Dutch*, ed. Jaap Guldemond, Gabriele Mackert, and Barbere Kooij (Rotterdam: NAi, 2004), pp. 63-65; Rachel Kent, "Time and Transformation in the Art of Yinka Shonibare MBE," in *Yinka Shonibare MBE*, ed. Rachel Kent (Munich, London, and New York: Prestel, 2008), 42-43. See also Purtich, this volume, pp. 10, 12, 17.

references to popular culture, as well. To signal that this is a contemporary interpretation of a nostalgic, old film through *Dorian Gray*. So, there are quite a few things going on there.

RPT: *The frame within the frame.*

YS: Yeah.

RPT: *In many of your works, you've dealt with the theme of the dandy. This has been commented on often, as exemplified by the personae depicted in* Diary of a Victorian Dandy, Dorian Gray, *your sculpture* Big Boy *(2002; page 11, fig. 1; pages 86-89), and others depicting a fluid sexuality, as well as your trenchant comments on "power relationships that find their expression in sexuality."[4]*

You demonstrate a deep sensitivity and awareness of the political and social oppressiveness of heteronormative society. Has that developed from your personal experience as a black man, that of being the "other," the "outsider," in society? Because it seems to me, at least, your work has empowered not only people of color, but women and gay people, as well.

YS: Absolutely. As a member of a minority group, I feel a sense of kindred spirit with all oppressed groups, and that is expressed in some of my interest in expressing the whole politics of sexuality in the world. Because I feel that all oppressed groups should fight together. I don't see the difference between discriminating against a gay person, a transgender person, or a woman, or a black person. Oppression is oppression, whichever way you want to look at it.

RPT: *You're an artist's artist, and especially an art historian's artist. Your knowing references to the art historical canon, from Gainsborough, Fragonard, and Goya, to Barbara Kruger and Cindy Sherman make you a darling of both art historians and artists.*

*But it is as much subversion as it is homage. Do you care
to comment on that, the way you use that, and the politics
of it?*

YS: In the United States, they had the Jim Crow laws of segregation. And I think within the art world there's a kind of Jim Crow thing that goes on. There are places you are supposed to go; there are places you are not supposed to go. And I refuse to do that. I can go anywhere I like. I can touch any part of art history, and I don't feel that I have to kind of go back to a village in Africa or something.

Picasso had the freedom to cherry-pick from African imagery, and I always joke that sometimes I feel like Picasso in reverse. I can just look like an anthropologist and look at European history and take whatever I want. White people have always done that. So, I've got the freedom to do that, too.

RPT: *So, appropriation is political to you.*

YS: Oh, absolutely. I have never heard of or seen anyone having a problem with Picasso taking things from Africa. And so why is it always like a big deal if an African artist does exactly the same thing?

RPT: *Picasso appropriated, amongst other reasons, to place
himself firmly within the canon, to reinforce his being an
heir to the canon. How do you feel about that?*

YS: Well, for whatever reason he may have done it, I feel that it still is a sort of European gaze. And I can have a sort of African gaze as well.

RPT: *The Driehaus Museum's exhibition series* A Tale
of Today *and its associated programs will largely focus
on artists of color. This has to do as much with the
appropriateness to the themes and subjects inspired by the
Museum, its collections and nineteenth-century building,
which artists of the African diaspora such as Kara Walker,
Fred Wilson, and yourself treat, as it does understandably
to being a corrective to the imbalance of representation.*

Would you care to comment on the eloquence and deftness
with which artists of color contend with and express this
burden of history?

YS: I think all of this is political stuff about agency, and I think it's great to know and to see the works of Kara Walker and Fred Wilson over the years. It's a kind of empowerment that artists have only been able to have, I would say, probably in the past maybe fifty years, if that. So, I think that it's great that a lot of artists of African origin, African-American artists, are taking control of their own expressions and also interrogating that sort of violent and oppressive history. But we've got a long way to go, so, I think that, actually, we're only just getting started.

This interview was conducted on December 17, 2018, in the London studio of Yinka Shonibare CBE. It has been edited for content and clarity.

SELECTED BIBLIOGRAPHY

Blum, Stella, ed. *Victorian Fashions and Costumes from "Harper's Bazar," 1867–1898*. New York, Dover, 1974.

Breward, Christopher. *The Hidden Consumer: Masculinities, Fashion and City Life, 1860-1914*. Manchester and New York: Manchester University Press, 1999.

Carlyle, Thomas. *Sartor Resartus: On Heroes and Hero Worship*. London: J. M. Dent; New York: E. P. Dutton, 1954.

Dolkart, Judith F. *Yinka Shonibare MBE: Magic Ladders*. Philadelphia: Barnes Foundation, 2014.

Feldman, Melissa E., and Ingrid Schaffner. *Secret Victorians: Contemporary Artists and a 19th-Century Vision*. London: Hayward Gallery, 1998.

Gott, Suzanne, et al., eds. *African-Print Fashion Now! A Story of Taste, Globalization, and Style*. Los Angeles: Fowler Museum at UCLA, 2017.

Guldemond, Jaap, Gabriele Mackert, and Barbere Kooij, eds. *Yinka Shonibare: Double Dutch*. Rotterdam: NAi, 2004.

Halls, Julie, and Allison Martino. "Cloth, Copyright, and Cultural Exchange: Textile Designs for Export to Africa at the National Archives of the UK." *Journal of Design History* 31, no. 3 (September 2018): 236-54.

Irvin, Kate, and Laurie Ann Brewer, eds. *Artist/Rebel/Dandy: Men of Fashion*. New Haven: Yale University Press/Museum of Art, Rhode Island School of Design, 2013.

Kent, Rachel, ed. *Yinka Shonibare MBE*. Munich: Prestel, 2008. Revised and expanded edition. London and New York: Prestel, 2014.

Kurlansky, Mark. *The Big Oyster: History on the Half Shell*. New York: Ballantine, 2006.

Lobel, Cindy R. *Urban Appetites: Food and Culture in Nineteenth-Century New York*. Chicago and London: University of Chicago Press, 2014.

Miller, Monica L. *Slaves to Fashion: Black Dandyism and the Styling of Black Diasporic Identity*. Durham and London: Duke University Press, 2009.

Nielsen, Ruth. "The History and Development of Wax-Printed Textiles Intended for West Africa and Zaire." In *The Fabrics of Culture: The Anthropology of Clothing and Adornment*, edited by Justine M. Cordwell and Ronald A. Schwarz, 467-98. The Hague, Paris, and New York: Mouton, 1979.

Parry, Linda. *British Textiles from 1850 to 1900*. New York: Canopy, 1993.

Perrot, Philippe. *Fashioning the Bourgeoisie: A History of Clothing in the Nineteenth Century*. Translated by Richard Bienvenu. Princeton: Princeton University Press, 1994.

Picton, John. *The Art of African Textiles: Technology, Tradition and Lurex*. London: Barbican Art Gallery/ Lund Humphries, 1995.

_____. "Undressing Ethnicity." *African Arts* 34, no. 3 (Autumn 2001): 66-73.

Shannon, Brent. *The Cut of His Coat: Men, Dress, and Consumer Culture in Britain, 1860–1914*. Athens: Ohio University Press, 2006.

Smith, Robert A. *A Social History of the Bicycle: Its Early Life and Times in America*. New York: American Heritage Press, 1972.

Takeda, Sharon Sadako, Kaye Durland Spilker, and Clarissa M. Esguerra. *Reigning Men: Fashion in Menswear, 1715–2015*. Los Angeles: Los Angeles County Museum of Art; Munich, London, and New York: Prestel, 2016.

Warner, Patricia Campbell. *When the Girls Came Out to Play: The Birth of American Sportswear*. Amherst and Boston: University of Massachusetts Press, 2006.

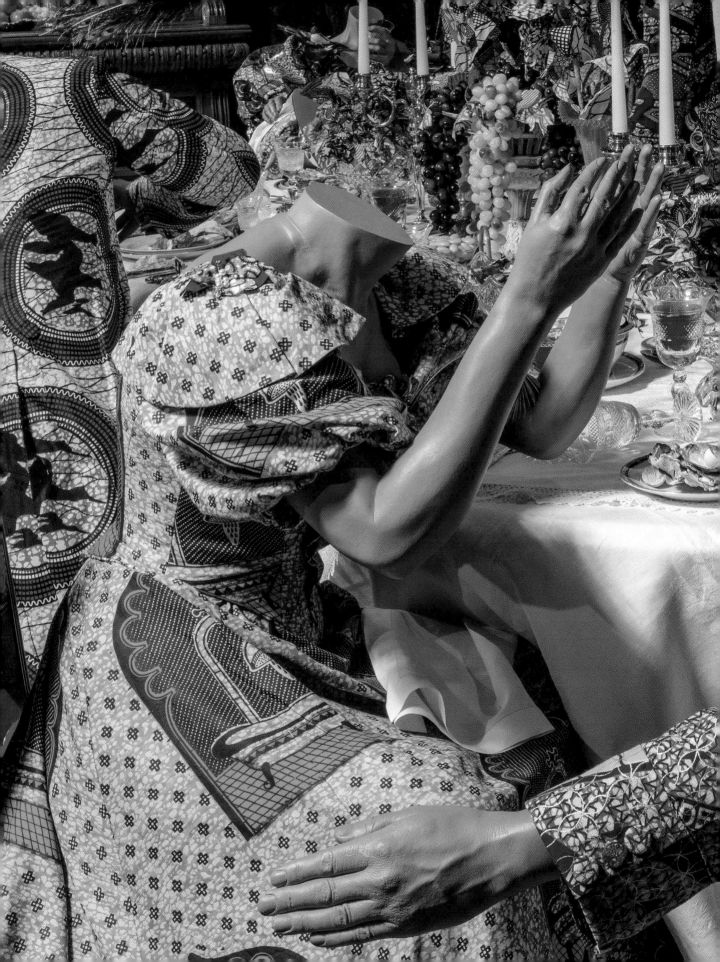

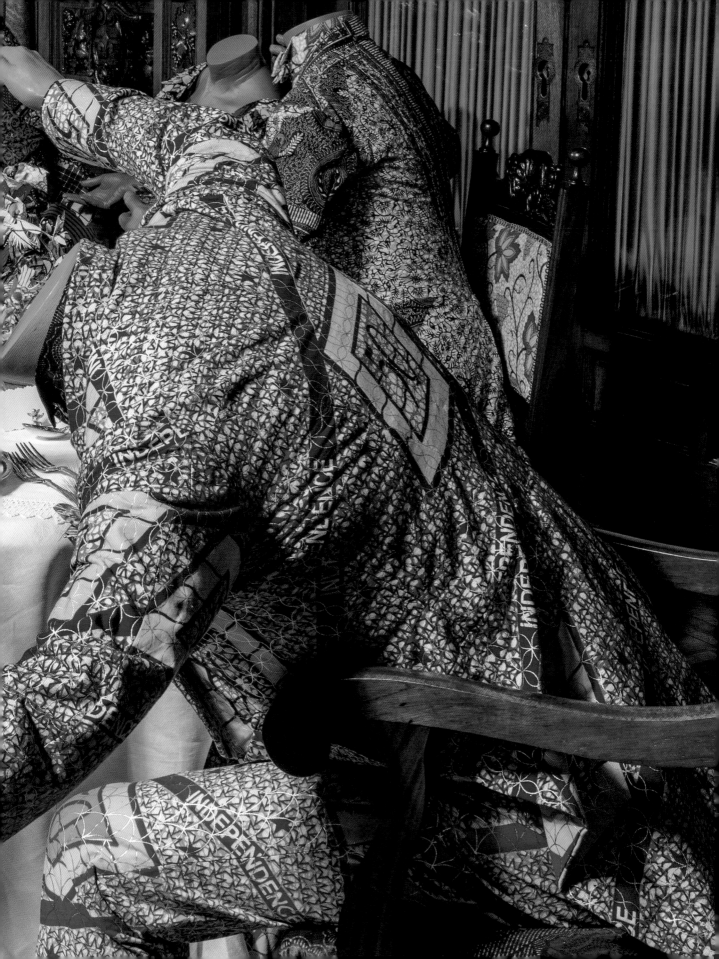

CATALOGUE

Upstairs, Downstairs

1997
16 hand-painted and stenciled Limoges plates,
glass-and-aluminum display cabinet, plastic,
plate stands, and double-sided laminated photograph
78 3/4 × 19 11/16 × 47 1/4 in. (200 × 50 × 120 cm)
Collection of Jack and Sandra Guthman, Chicago

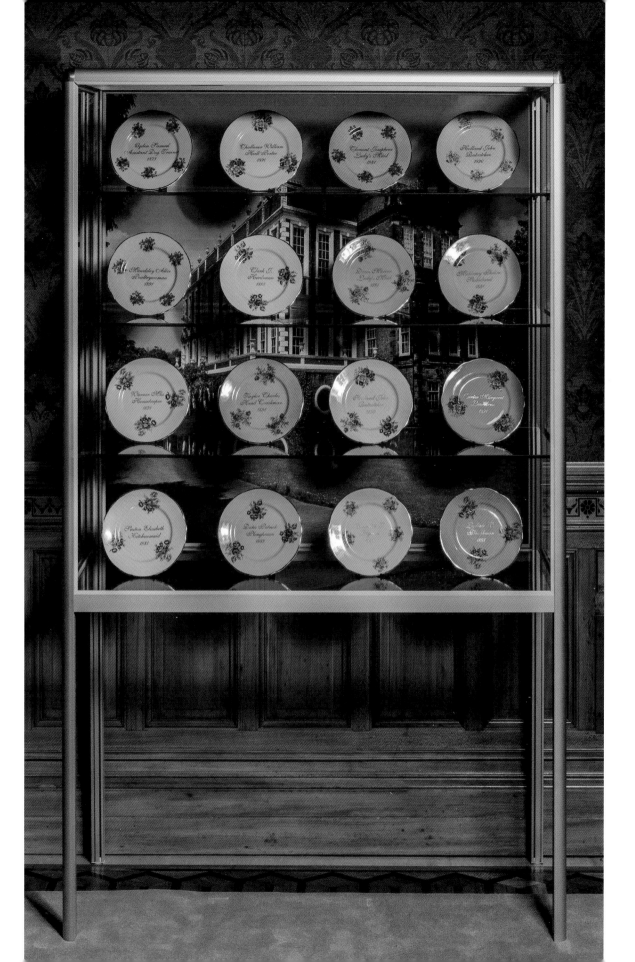

Diary
of a
Victorian
Dandy

1998
Diary of a Victorian Dandy: 11.00 Hours
Diary of a Victorian Dandy: 14.00 Hours
Diary of a Victorian Dandy: 17.00 Hours
Diary of a Victorian Dandy: 19.00 Hours
Diary of a Victorian Dandy: 03.00 Hours

5 chromogenic photographs
48 × 72 in. (21.9 × 182.9 cm)
The Collection of John and Amy Phelan

Diary of a Victorian Dandy: 11.00 Hours
1998

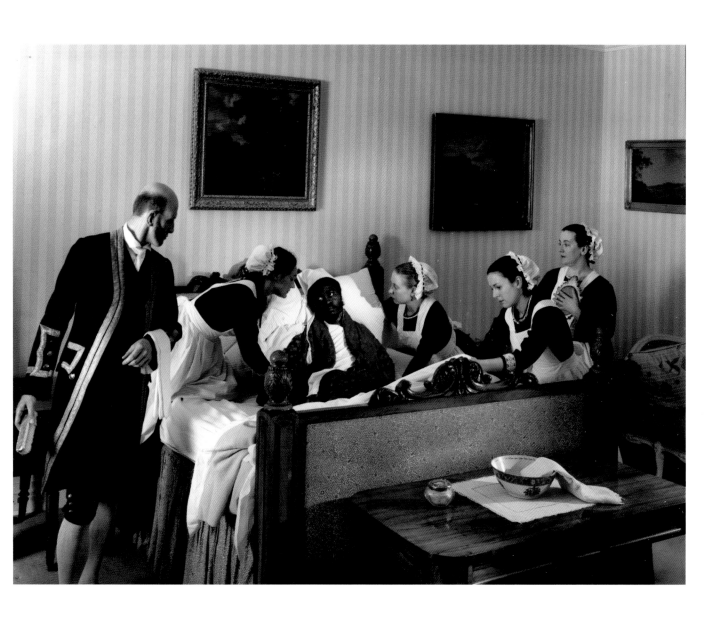

Diary of a Victorian Dandy: 14.00 Hours
1998

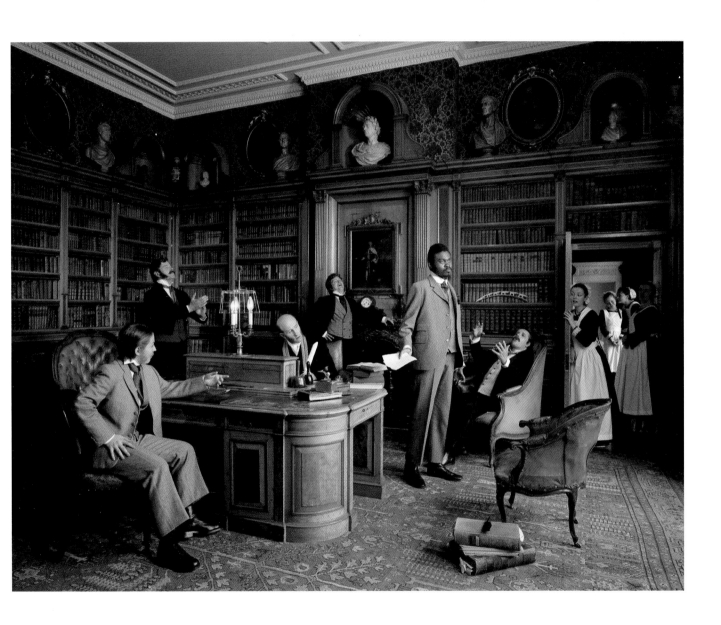

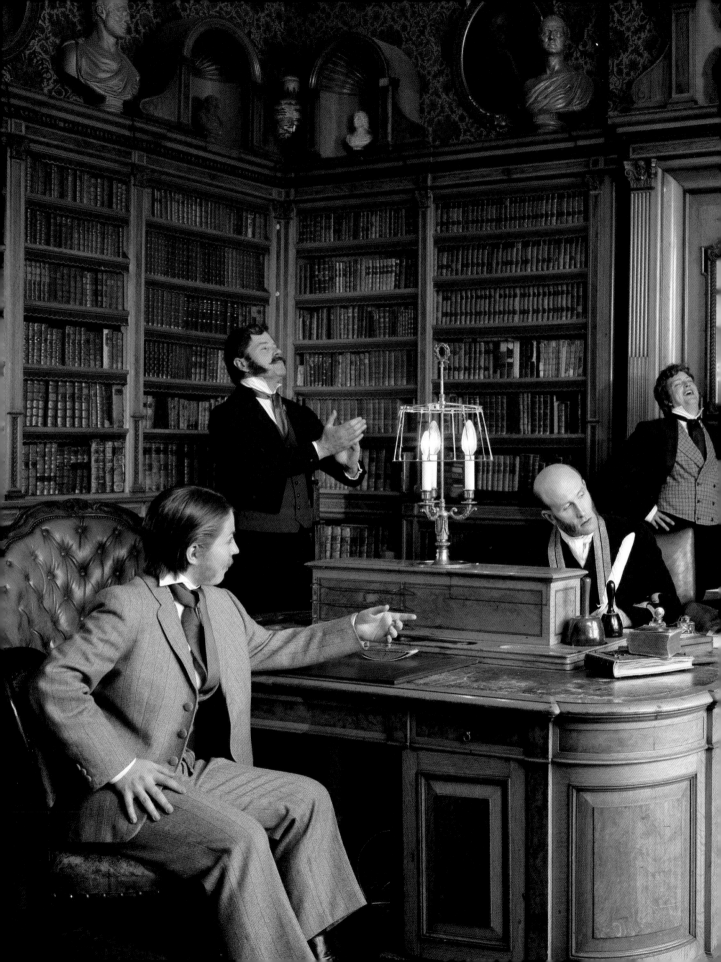

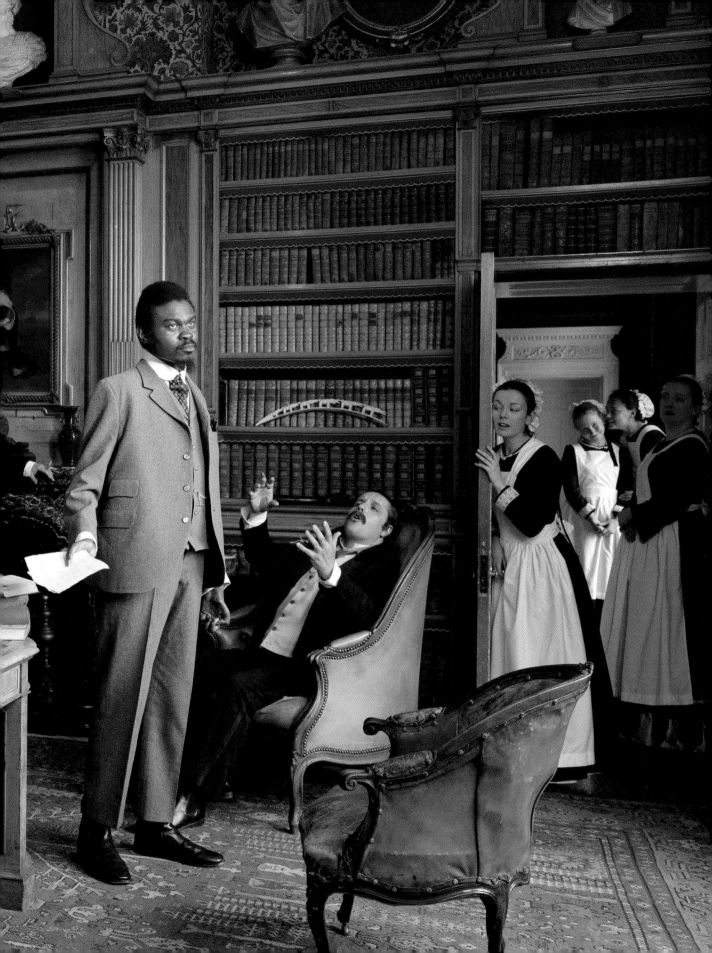

Diary of a Victorian Dandy: 17.00 Hours
1998

Diary of a Victorian Dandy: 19.00 Hours
1998

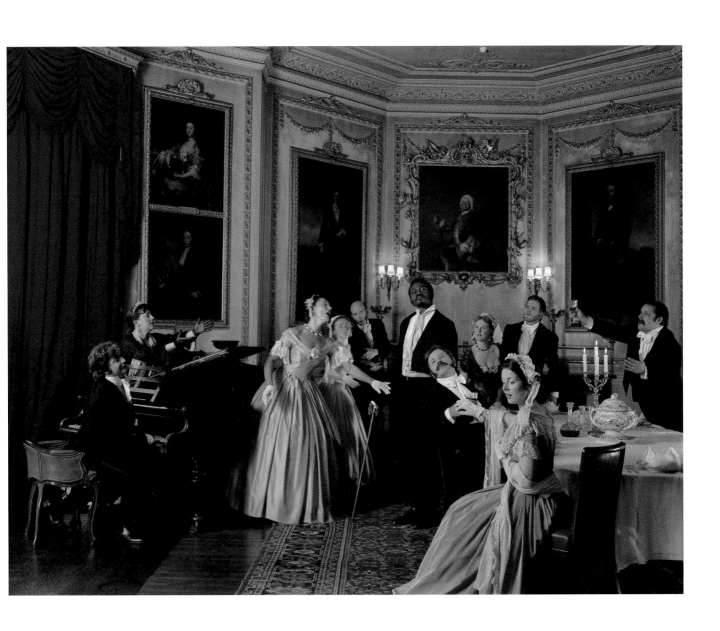

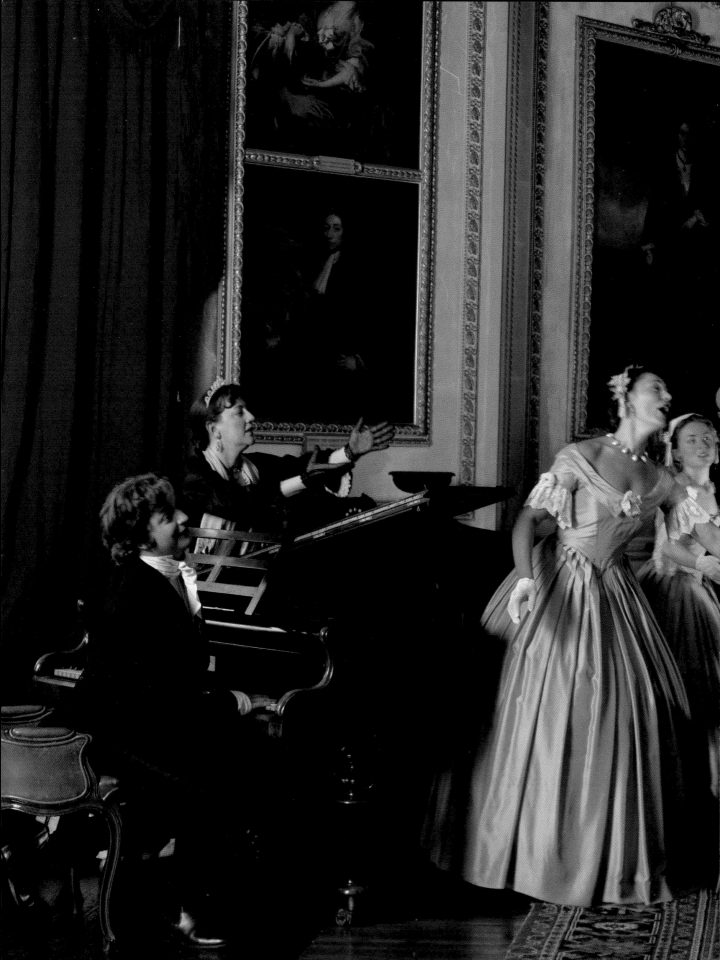

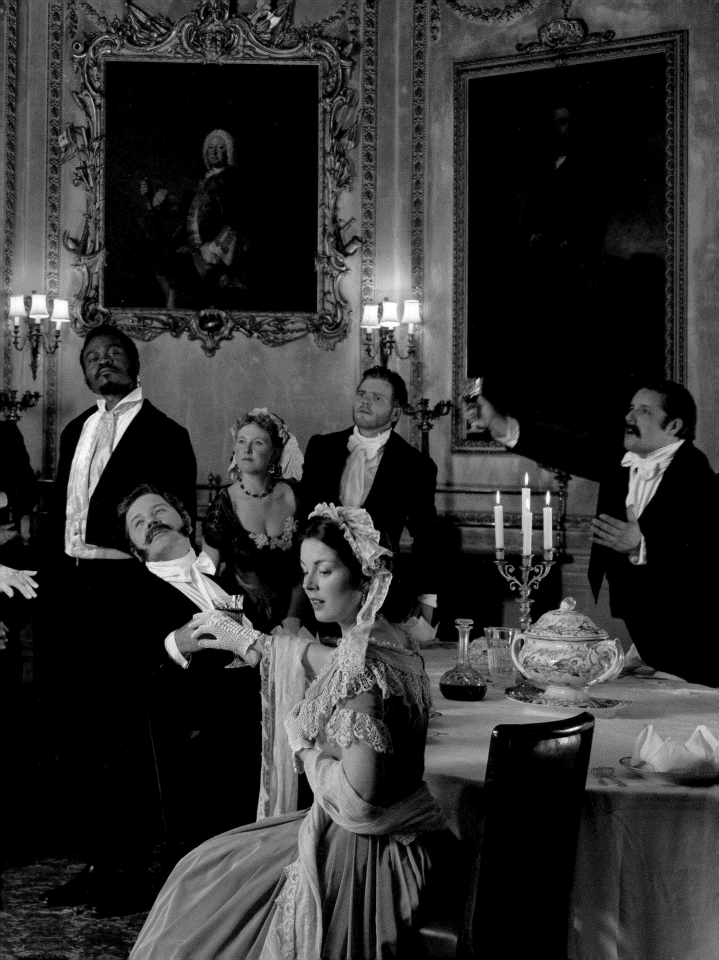

Diary of a Victorian Dandy: 03.00 Hours
1998

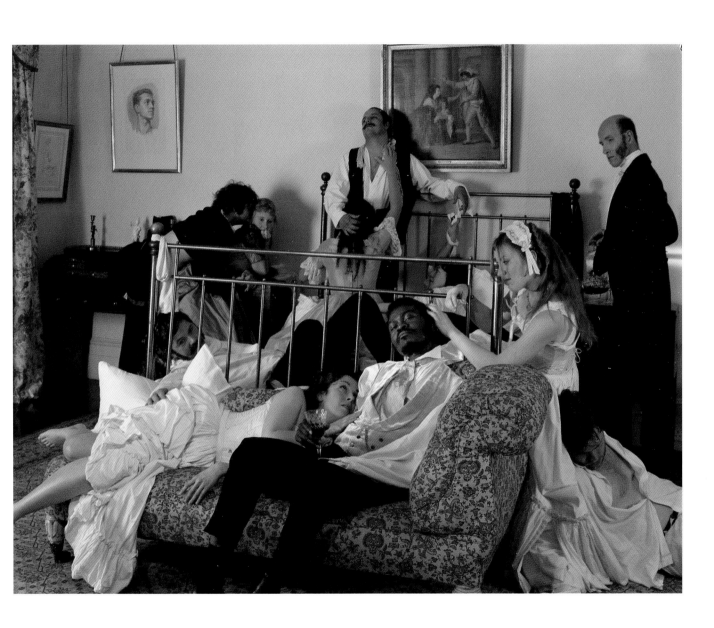

Dorian Gray

2001
11 black-and-white photographs
and 1 chromogenic photograph
30 × 37 ½ in. (76.2 × 95.25 cm)
The Collection of Glenn and Amanda Fuhrman,
NY, Courtesy of the FLAG Art Foundation

Dorian Gray
2001

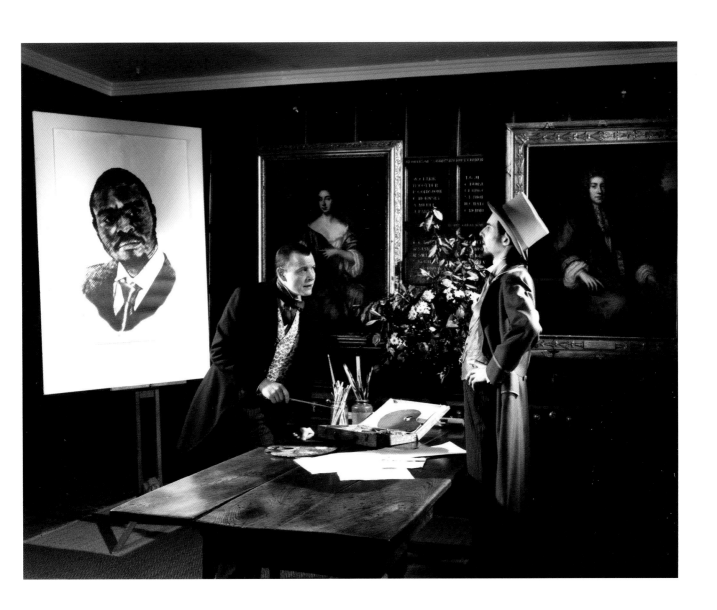

Dorian Gray
2001

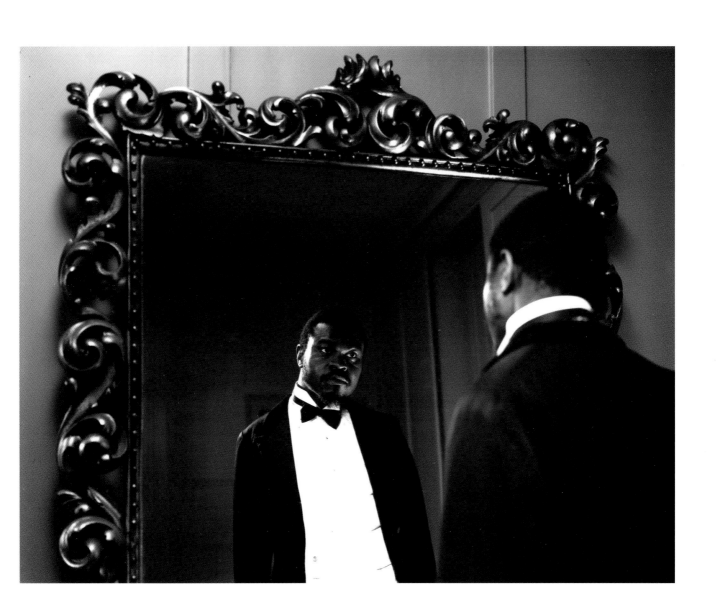

Dorian Gray
2001

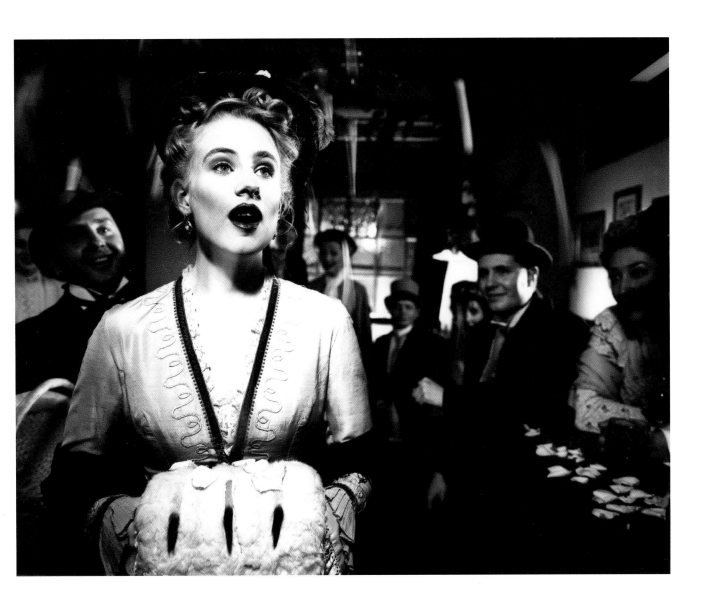

Dorian Gray
2001

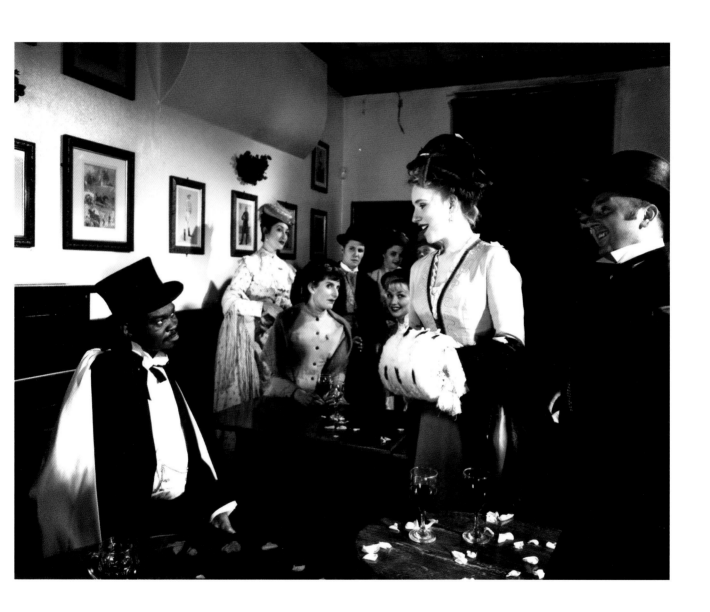

Dorian Gray
2001

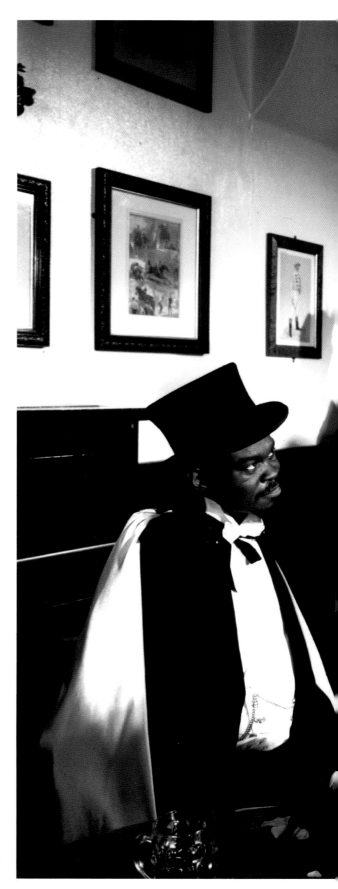

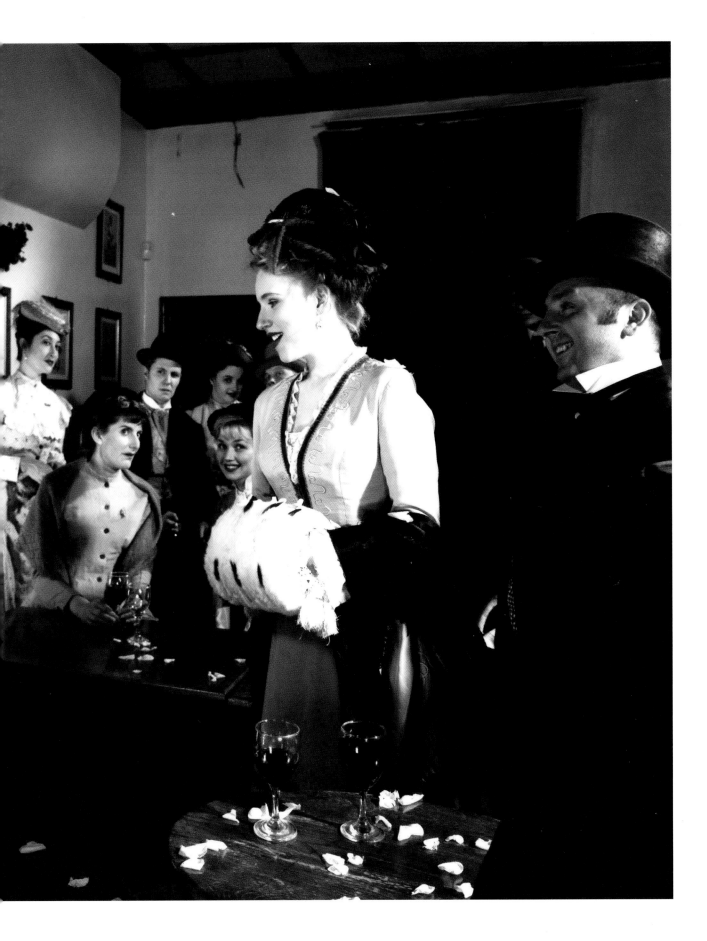

Dorian Gray
2001

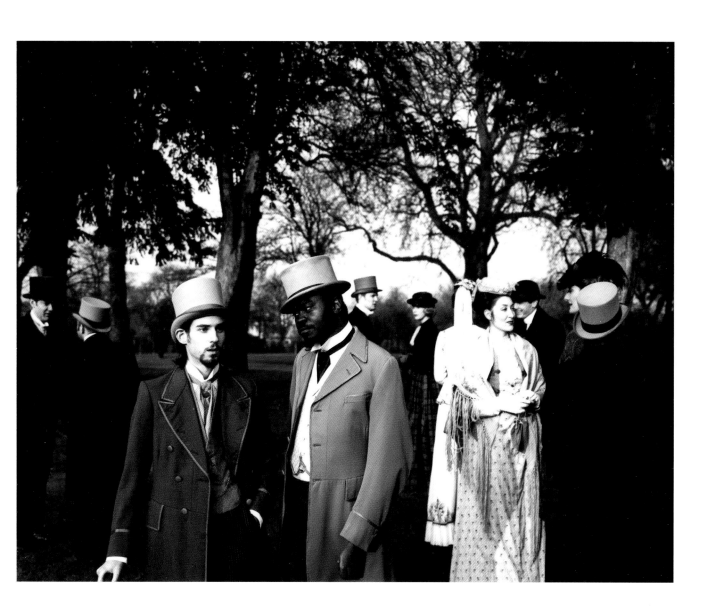

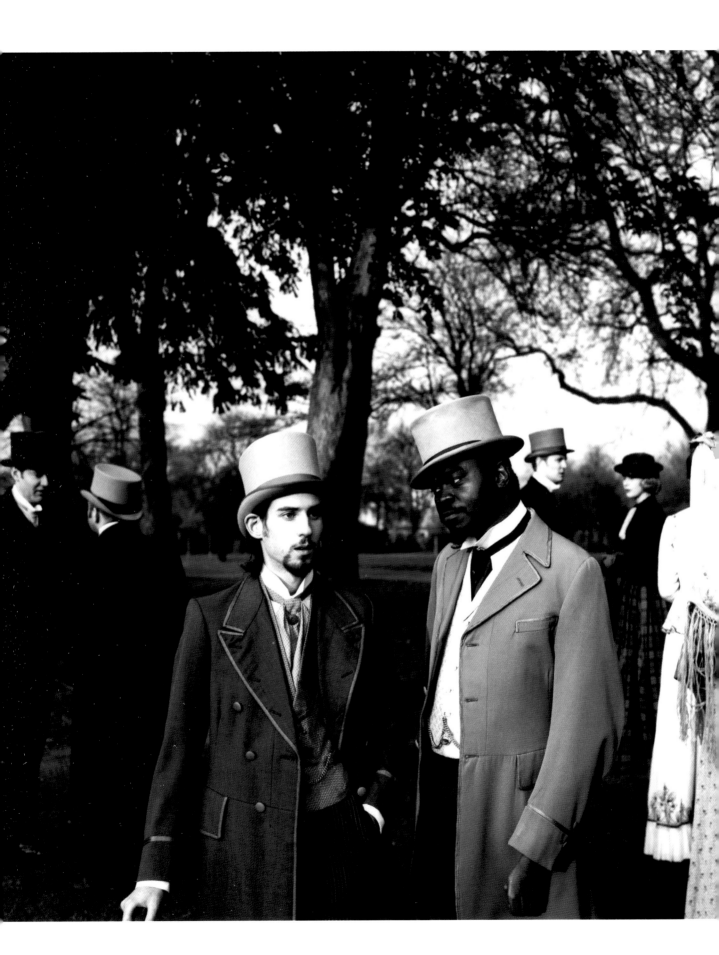

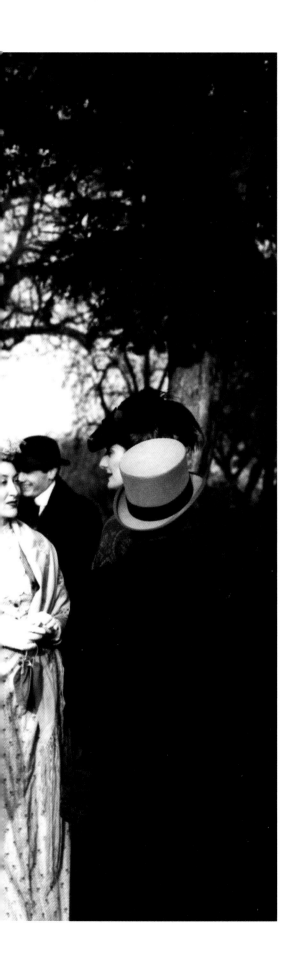

Dorian Gray
2001

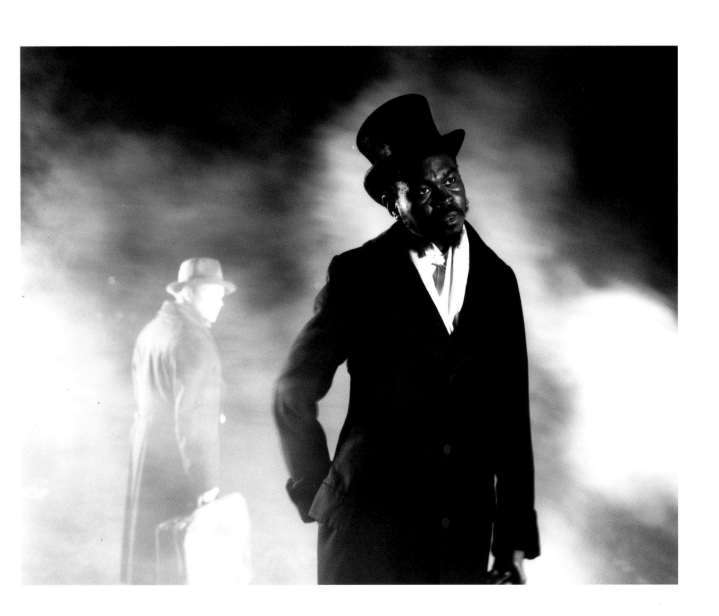

Dorian Gray
2001

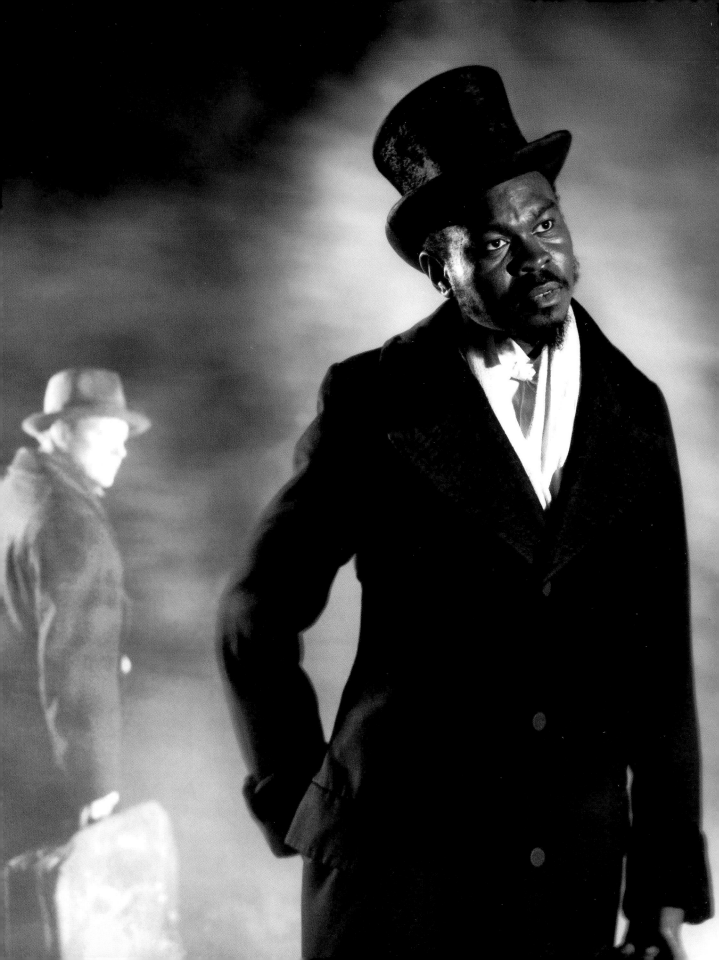

Dorian Gray
2001

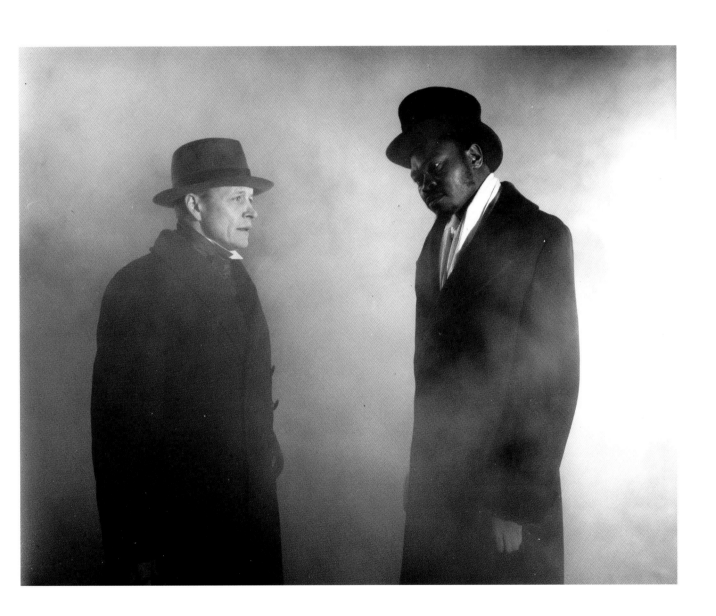

Dorian Gray
2001

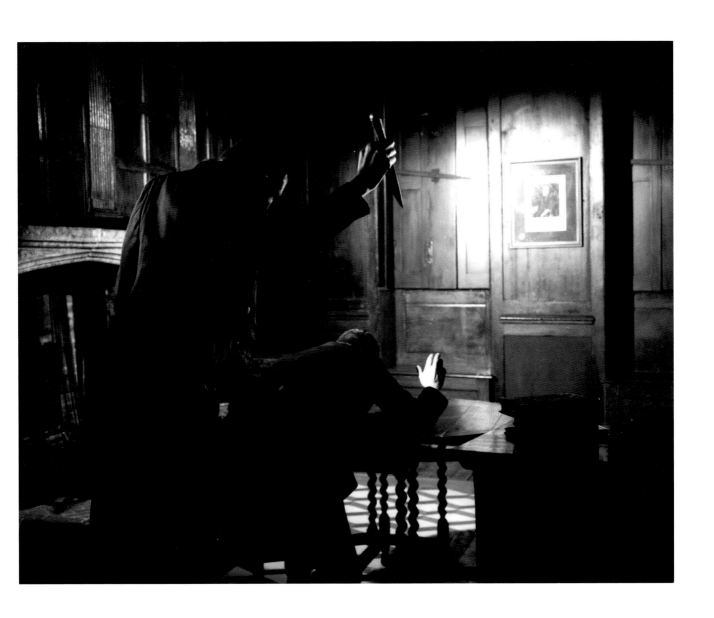

Dorian Gray
2001

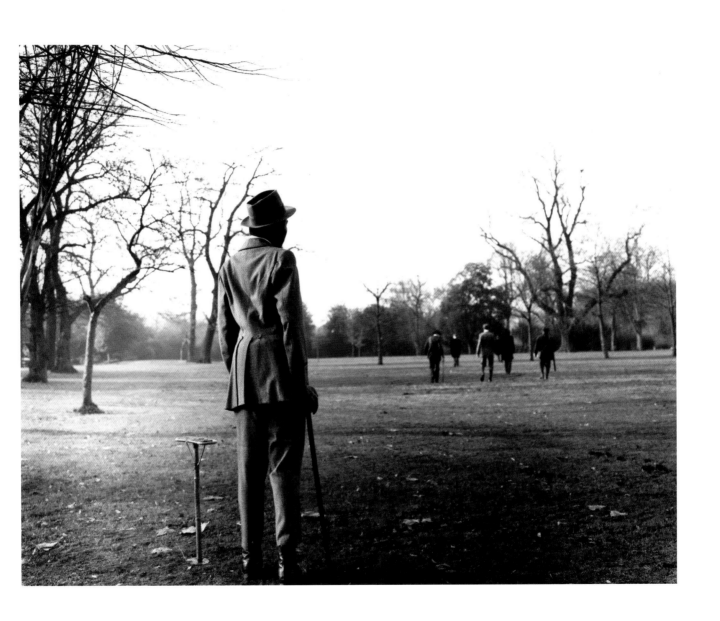

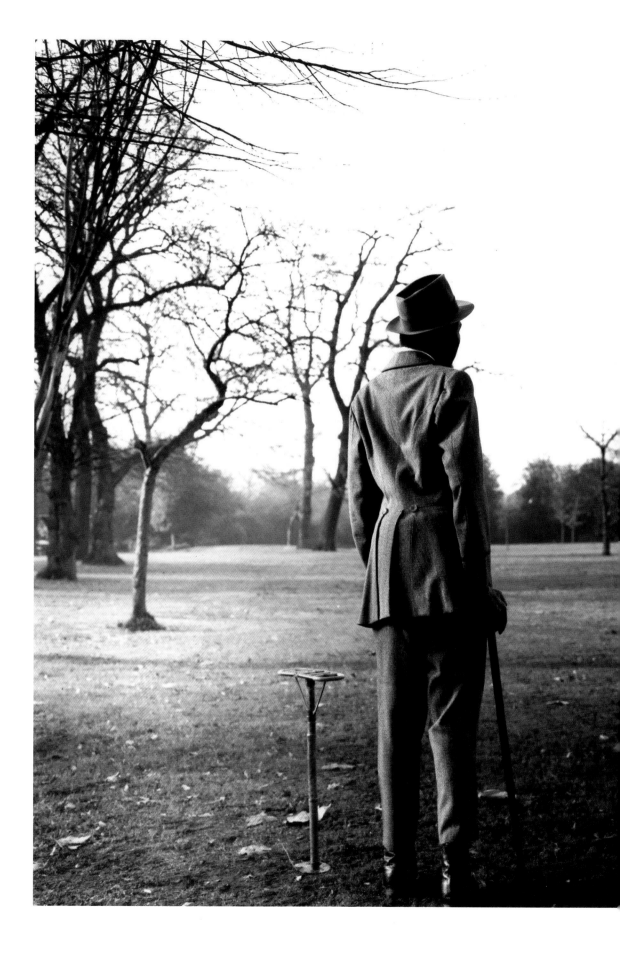

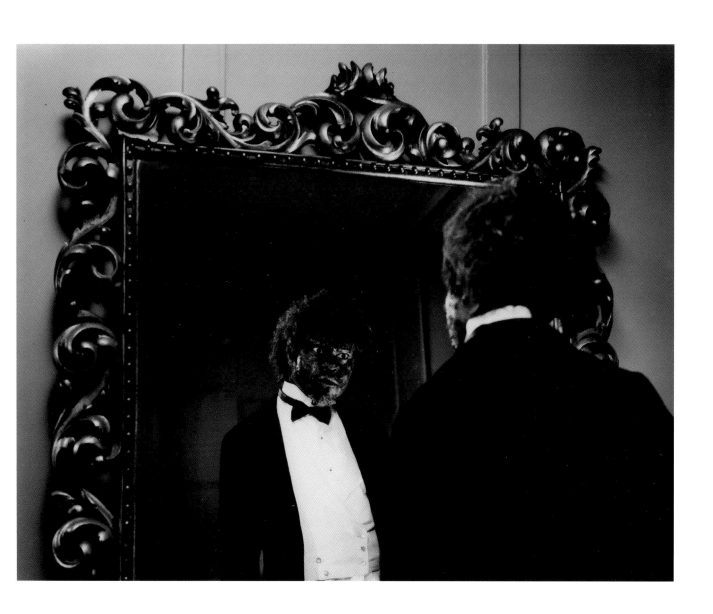

Dorian Gray
2001

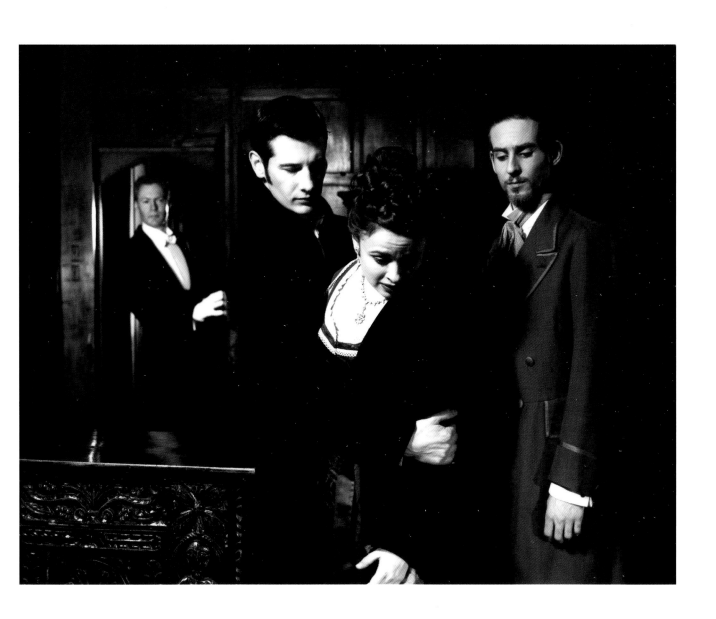

Dorian Gray
2001

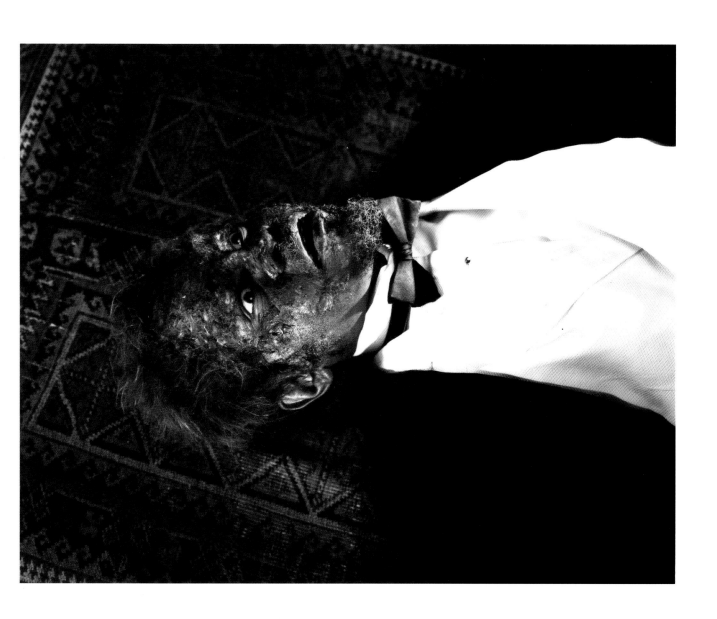

Big Boy
2002
Wax-printed cotton fabric and fiberglass
84 × 66 × 55 in. (215 × 170 × 140 cm)
The Art Institute of Chicago
Gift of Susan and Lewis Manilow, 2004.759

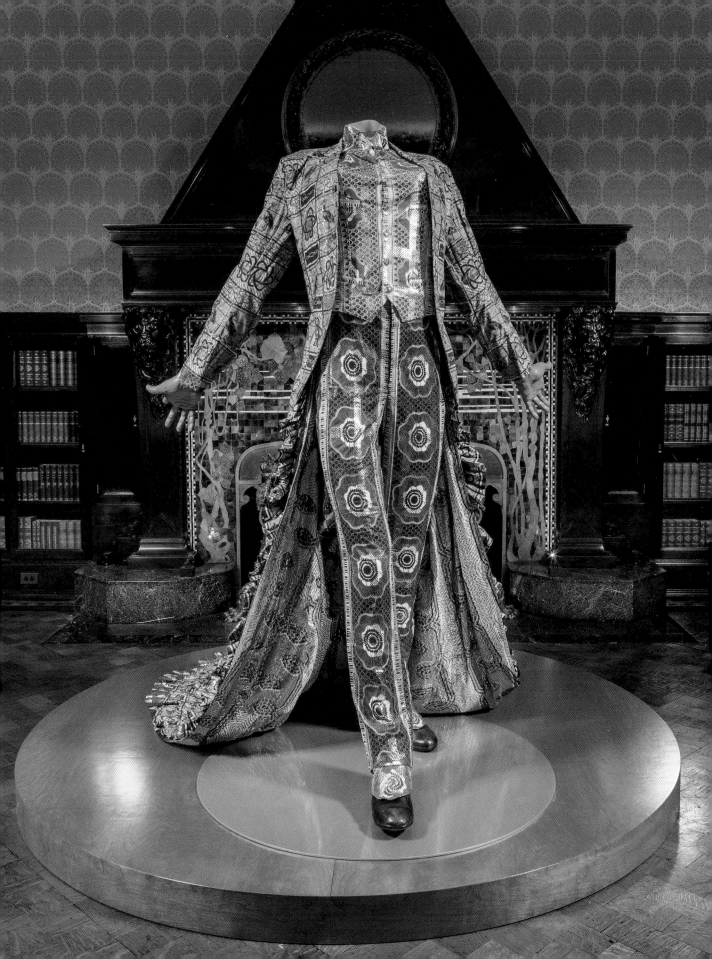

Big Boy
2002

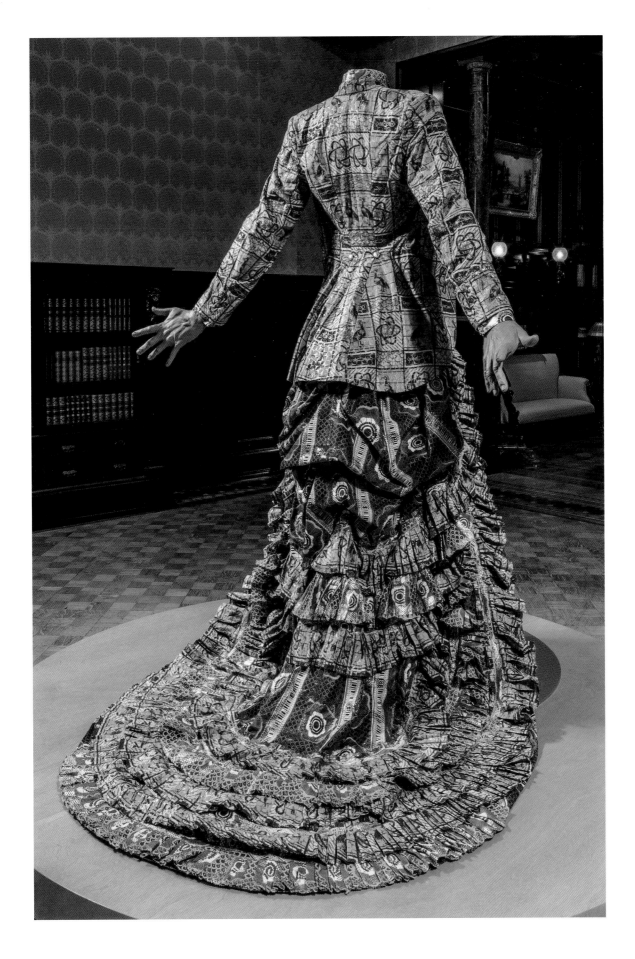

Child on Unicycle

2005

Metal, fabric, resin, and leather

79 × 46 × 38½ in. (200.7 × 116.8 × 97.8 cm)

American Masters Collection I

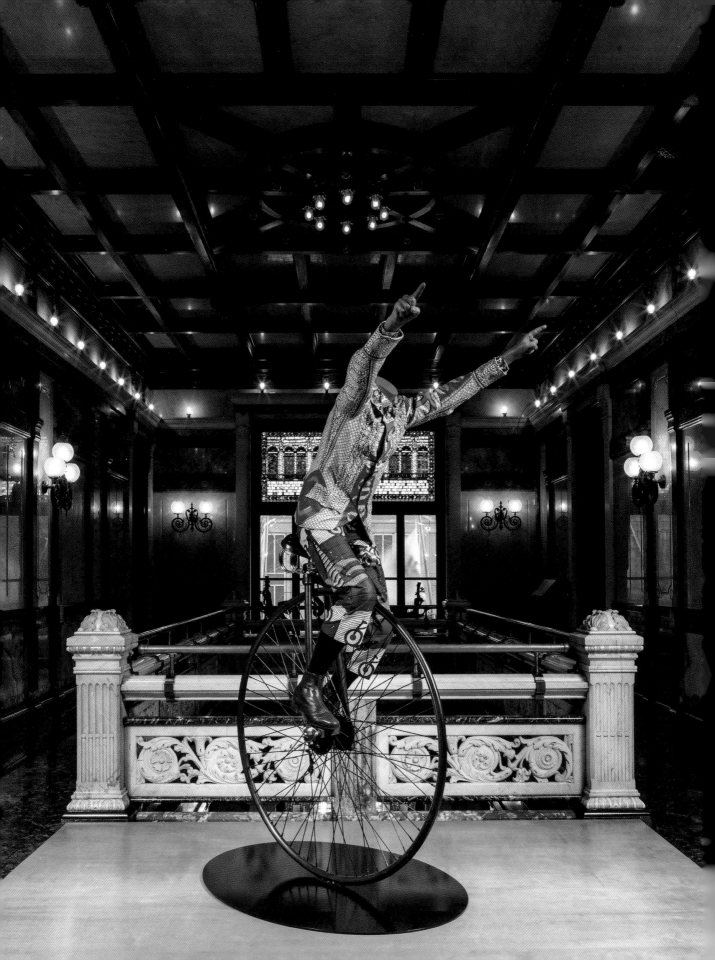

Child on Unicycle
2005

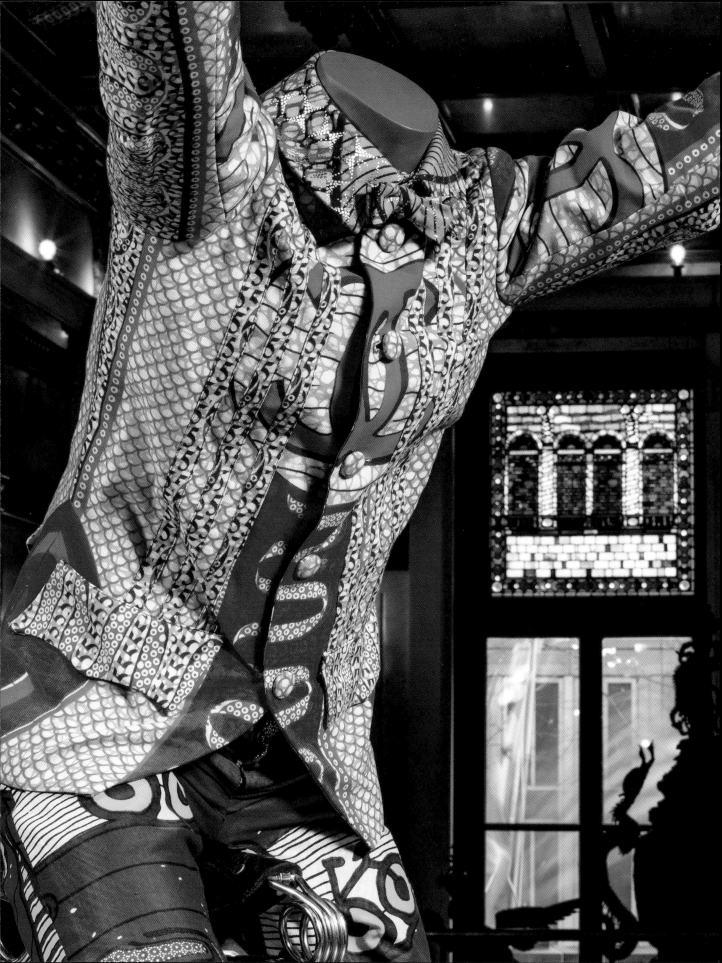

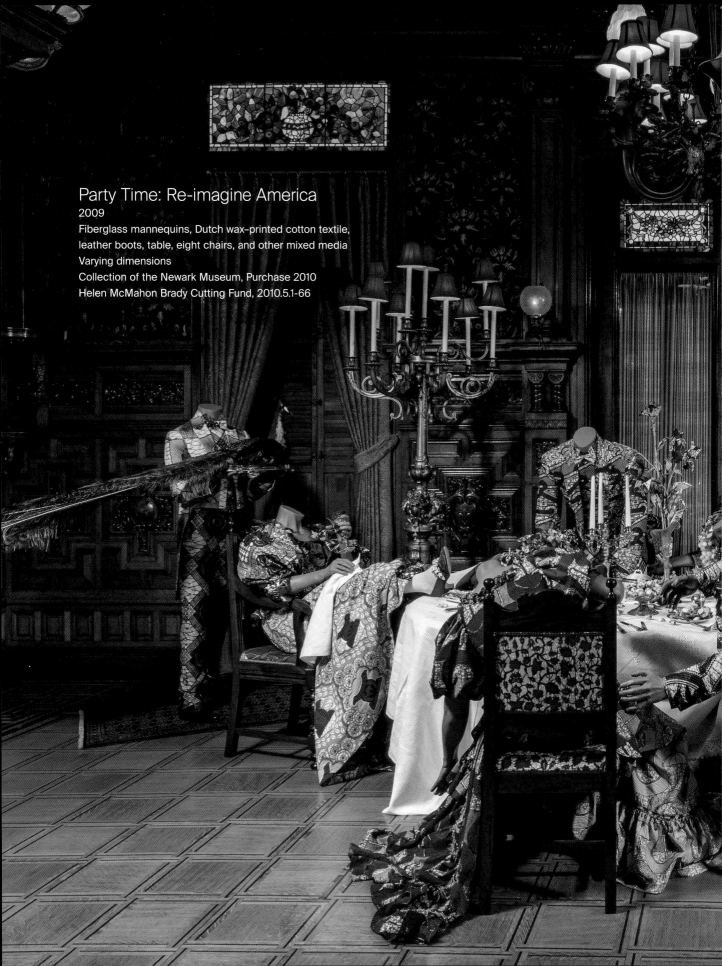

Party Time: Re-imagine America
2009
Fiberglass mannequins, Dutch wax–printed cotton textile,
leather boots, table, eight chairs, and other mixed media
Varying dimensions
Collection of the Newark Museum, Purchase 2010
Helen McMahon Brady Cutting Fund, 2010.5.1-66

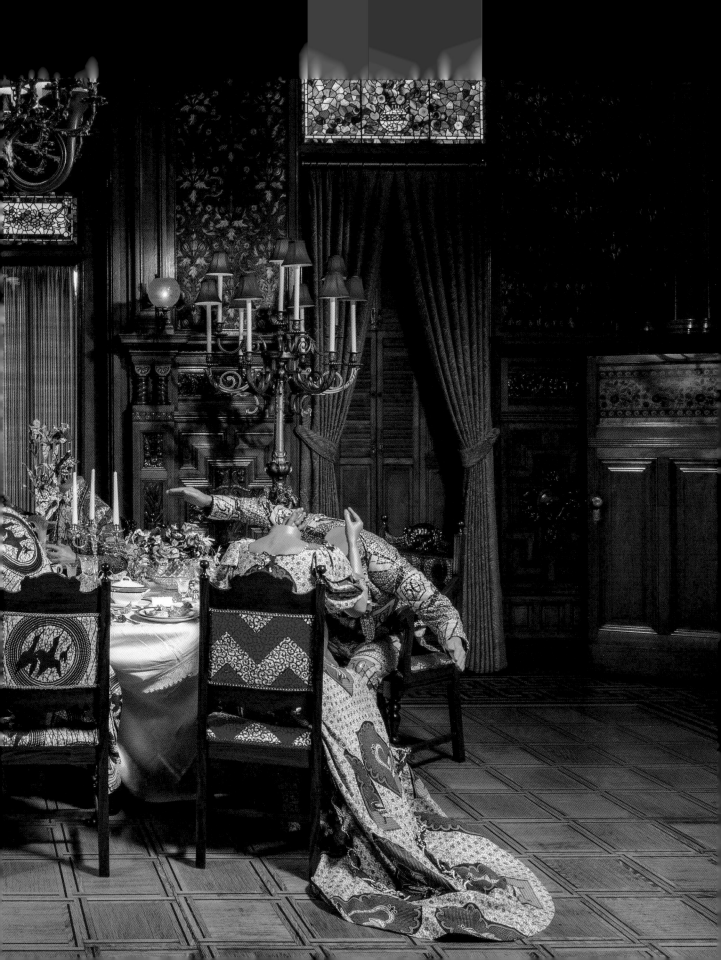

Party Time: Re-imagine America
2009

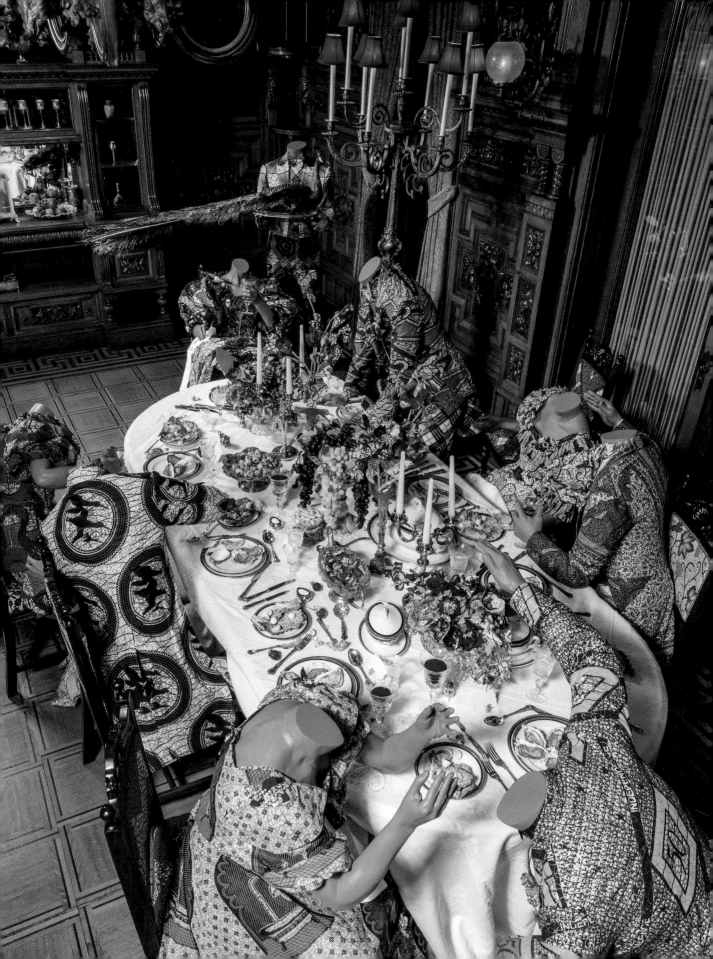

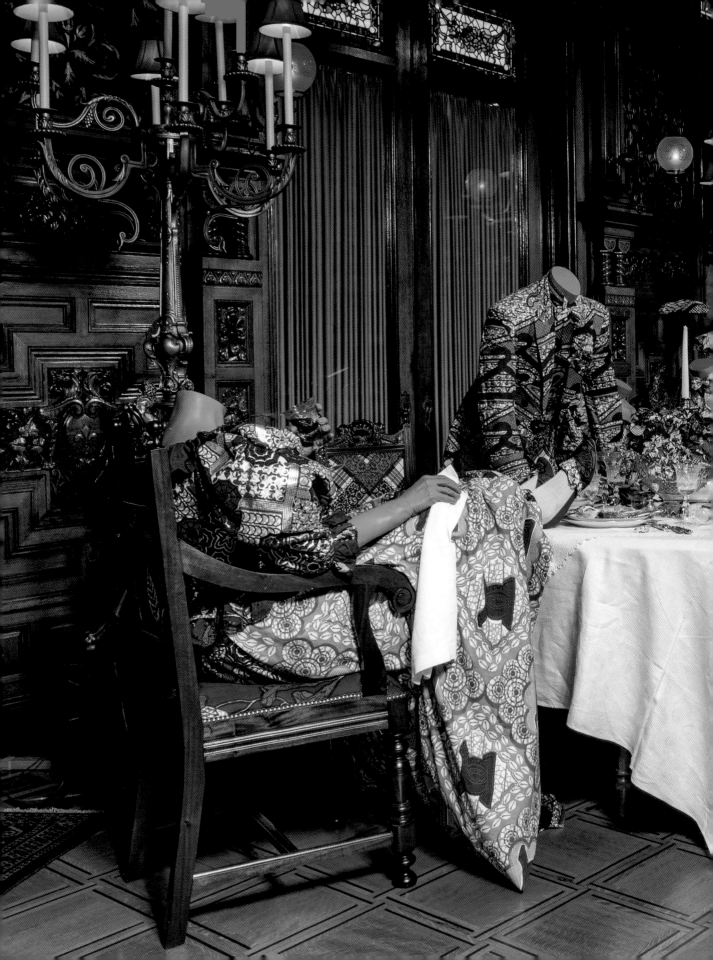

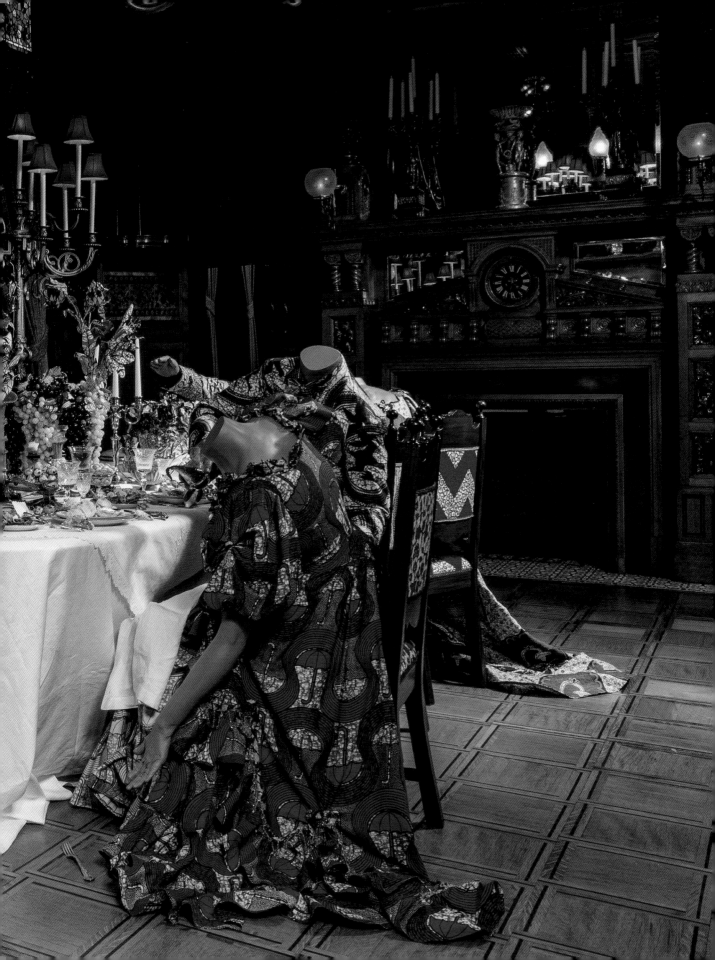

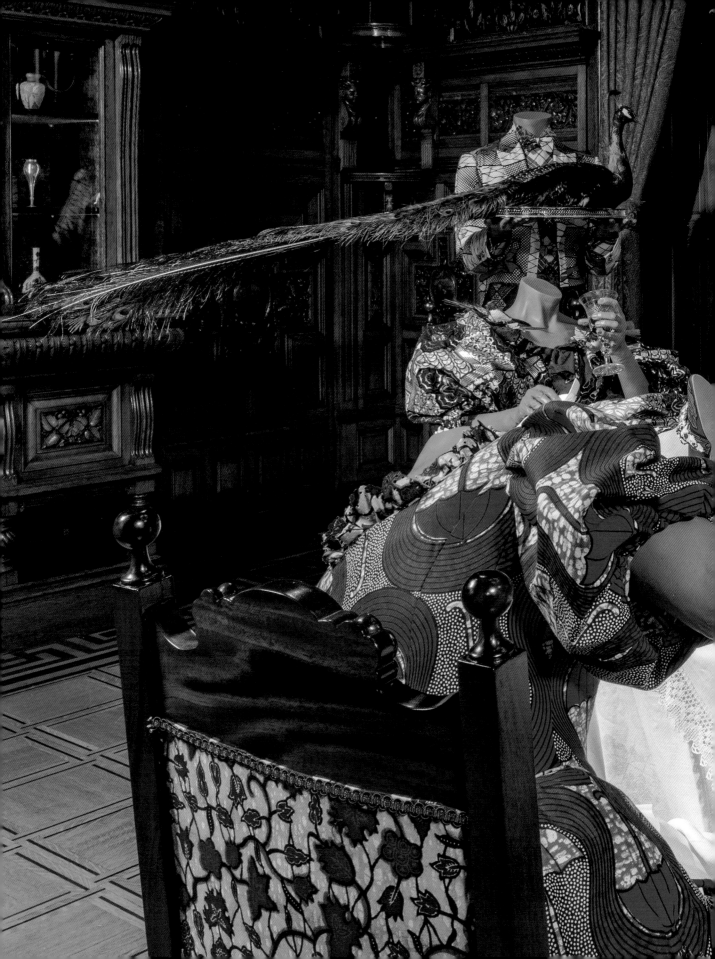

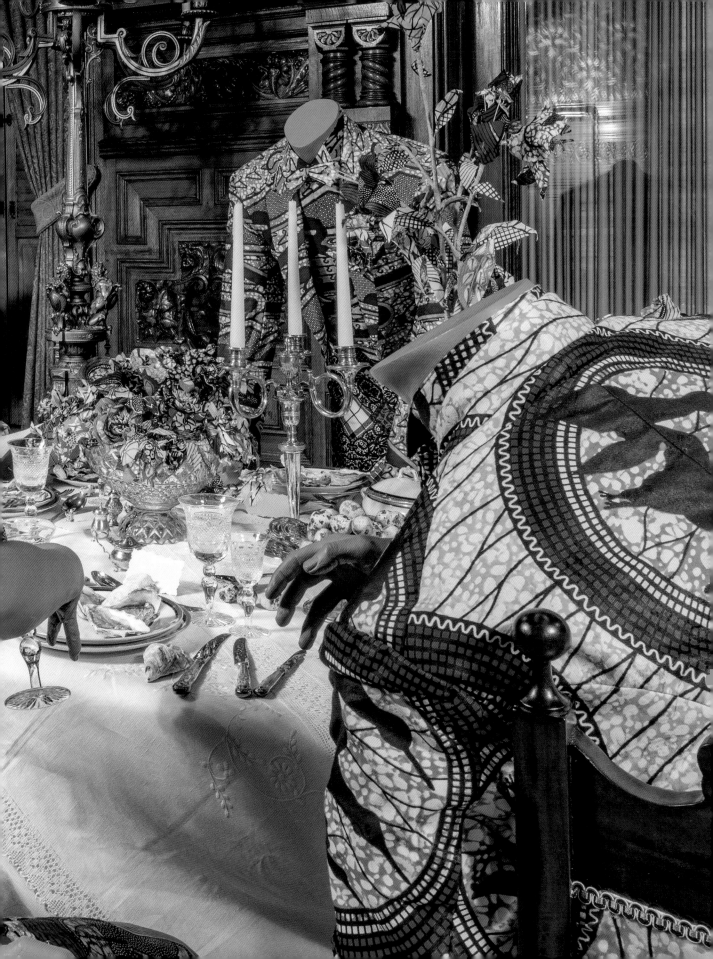

ACKNOWLEDGMENTS

The Richard H. Driehaus Museum would like to thank the following for their assistance on
A Tale of Today: Yinka Shonibare CBE

American Masters Collection I
Brian Hearn

The Art Institute of Chicago
James Rondeau
Sarah Guernsey
Emily Heye
Anna Simonovic

EXPO Chicago
Tony Karman
Stephanie Cristello

The Collection of Glenn and Amanda Fuhrman, NY, Courtesy of the FLAG Art Foundation
Glenn and Amanda Fuhrman
Risa Daniels

Jack and Sandra Guthman

Sam Holden Agency

James Cohan Gallery
Jane Cohan
Yvonne Zhou

JNL Graphic Design
Jason Pickleman
Ashley Ryann
Mia Hopkins

Marzena Mellin

Museum of Contemporary Art Chicago
Madeleine Grynsztejn
Naomi Beckwith
January Parkos Arnall

The Newark Museum
Ulysses Grant Dietz
Andrea Ko
Emily Laverty
David Bonner

PAVE Communications & Consulting
Sascha Freudenheim

The Collection of John and Amy Phelan
John and Amy Phelan
Emily Hoerdemann

Sotheby's
Gary Metzner
Lisa Dennison
Elizabeth Webb

Lowery Stokes Sims

Studio Blue
Cheryl Towler Weese
Brad Sturm
Joel De Leon

Kekeli Sumah

In closing, we would like to acknowledge our entire Driehaus Museum team, who devote their hard work and passion to these projects on a daily basis.

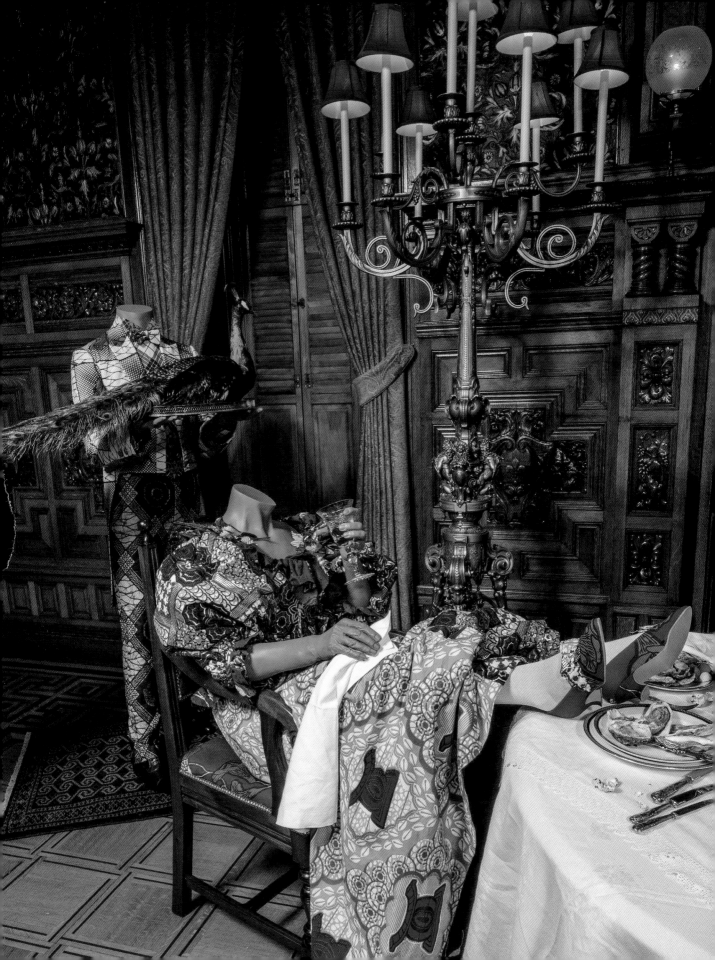

Published by the Richard H. Driehaus Museum and distributed by the University of Chicago Press on the occasion of the exhibition *A Tale of Today: Yinka Shonibare CBE*, organized by the Richard H. Driehaus Museum and on view March 2–September 29, 2019.

A TALE OF TODAY

The exhibition and publication were made possible, in part, by:
 Eugene and Jean Stark
 Gary Metzner and Scott Johnson
 The Richard H. Driehaus Annual Exhibition Fund

Additional support is provided by
The Joyce Foundation

Library of Congress Control Number: 2019901924

ISBN: 978-0-692-18841-5

Exhibition Curator: Richard P. Townsend
Catalogue Editor: Jane Friedman
Project Manager: Liz Tillmanns

Designed by JNL Graphic Design: Jason Pickleman, Ashley Ryann, and Mia Hopkins, Chicago
Printed by M&G, Chicago

Distributed by the University of Chicago Press
www.press.uchicago.edu

Front cover:
Yinka Shonibare CBE (British/Nigerian, b. 1962)
Diary of a Victorian Dandy: 19.00 Hours (detail), 1998
Chromogenic photograph
The Collection of John and Amy Phelan

Back cover:
Yinka Shonibare CBE (British/Nigerian, b. 1962)
Party Time: Re-imagine America (detail), 2009
Fiberglass mannequins, Dutch wax–printed cotton textile, leather boots, table, eight chairs, and other mixed media
Varying dimensions
Collection of the Newark Museum
Purchase 2010, Helen McMahon Brady Cutting Fund, 2010.5.1-66

Photography Credits:

Diary of a Victorian Dandy
Dorian Gray
 Images courtesy of James Cohan, New York

Upstairs, Downstairs
Big Boy
Child on Unicycle
Party Time: Re-imagine America
 In situ at the Richard H. Driehaus Museum
 Photography by Michael Tropea